ELEPHANT AND CASTLE

A HISTORY

STEPHEN HUMPHREY

AMBERLEY

First published 2013

Amberley Publishing
The Hill, Stroud
Gloucestershire, GL5 4EP

www.amberleybooks.com

Copyright © Stephen Humphrey, 2013

The right of Stephen Humphrey to be identified as the Author
of this work has been asserted in accordance with the
Copyrights, Designs and Patents Act 1988.

British Library Cataloguing in Publication Data.
A catalogue record for this book is available from the British Library.

ISBN 978 1 84868 780 6

Typesetting and Origination by Amberley Publishing.
Printed in Great Britain.

Contents

Acknowledgements

Gratitude is due to Peter Shilham and Stephen Potter for reading my text and for making many useful comments. I am grateful too to the Transport Treasury, the Louvre in Paris, the London Transport Museum, the Dean and Chapter of Westminster, *Express Newspapers* and the Local History Library and Archive in Southwark for their willingness to allow their pictures to be used in the book; and to Alan Godfrey Maps (www.alangodfreymaps.co.uk) for permission to use extracts from two maps. I am especially grateful to the *South London Press* for permission to quote from the great series of reminiscences published in 1957/58, when the paper had offices at the Elephant. I should like to state that comments on my text and further memories of the Elephant and Castle would be most welcome.

S. C. H.

Introduction
The Elephant and Castle
in its Heyday

The Elephant and Castle was once known as the 'Piccadilly Circus of South London'. It is still one of the best-known places south of the river. It has long been the hub of a big wheel of important roads that connect to several bridges over the Thames, and at one time it was a hub of life. This book discusses the story of the district over several centuries, but it concentrates on the period between around 1850 and the beginning of the Blitz in 1940. This was the period that I term the Elephant's heyday. Large stores, countless smaller shops, pubs, restaurants, places of entertainment and good transport connections were the lifeblood of the old Elephant, and these attractions drew many people from a distance. The pre-war Elephant had a wealth of enterprise and life. It was mostly on a small scale – a huge mosaic of independent enterprise – with large institutions providing the chief landmarks. This book is a lament for the destruction of that successful heyday by severe wartime bombing, subsequent unsympathetic redevelopment by the London County Council and economic decline brought about by causes that were not necessarily local.

The White Horse and the Elephant and Castle

The locality took its present name from a public house, which is first recorded there in 1765, not so far back as one might have expected. Previously, from 1641, there had been a farrier's workshop on the site, which was called the White Horse from at least 1672. The junction and the village around it had been known as Newington for many centuries. In 1325, one source used the name Newyngton juxta Suthwerk – Newington next to Southwark – but until the eighteenth century there was still a green belt south of the old town of Southwark, so Newington had remained a village outside London. South of it were the fields of rural Walworth. In the second half of the eighteenth century, great change came as a result of the opening in 1750 of Westminster Bridge. This was the first rival in central London to Old London Bridge, which had enjoyed a monopoly for hundreds of years. New Kent Road was laid out in the 1750s to connect

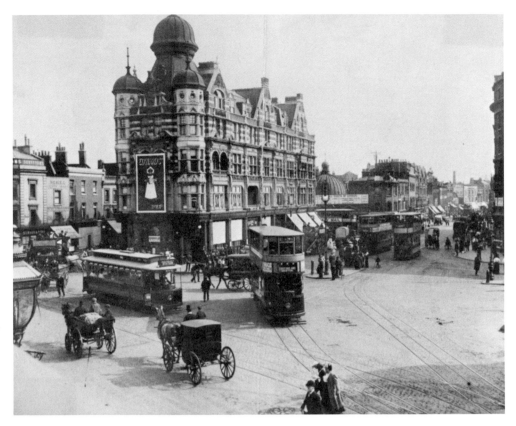

The Elephant and Castle pub presiding over the junction, with the dome of the Underground station behind, Newington Butts to the right and Stimson's Corner to the left.

the new bridge with the (Old) Kent Road. This change made an old junction a much more important one, and no doubt prompted the conversion of the farrier's workshop into a public house. Almost certainly, little thought was given to the change of name at the time, with no expectation that it would become one of the most familiar names in South London.

The first known licensee was George Frost. His pub in 1765 was probably the rather rustic affair depicted by Rowlandson at the end of the eighteenth century. It was to be rebuilt in grand Georgian style in 1818 and then in stupendous Victorian fashion by John Farrer in 1898. This last building, which comfortably dominated the junction, was demolished in 1959. The sign itself, which means an elephant with a *howdah* (or large enclosed seat for riders) on its back, is a very ancient one throughout Europe and the Middle East. It originated in India and began to spread from there more than 2,300 years ago. This long history of the sign is discussed below. It must be emphasised that it is a considerably more ancient sign than its relatively modern use at Newington. It had become a common heraldic badge centuries before it arrived at our junction, as familiar as badges such as the Lamb and Flag, and lions and harts in various colours. In the vast majority of cases, there was no particular allusion in choosing the badge.

The only specific allusions were naturally made by those who dealt with real elephants: companies trading with Africa and Asia, cutlers (who used ivory for handles) and military units in British India such as the 10th Madras Infantry, to whose soldiers living elephants with *howdahs* were as commonplace as red double-decker buses are to us.

The Life of the Old Elephant

The old Elephant was a vastly more important place for shopping than it is today. Until 1940, shops lined every approach road to the junction for some distance. Think of Newington Butts today: it is completely devoid of shops, and is a blank and uninteresting street. Up to 1940, however, it was full of shops and of life. Even as late as the 1960s, the Elephant end of the Walworth Road was lined with shops. Many people will remember when Baldwin's the herbalist's occupied the shop on the corner of Elephant Road. And what replaced those shops in Walworth Road? Merely the unkempt waste ground in front of the Heygate Estate, which will soon pass into history itself. The post-war transformation of lively streets into dull and dismal places is striking.

Tarn's, in Newington Causeway and New Kent Road, was the doyen of the Elephant's shops. It was a huge department store housed in elegant premises, which were the equal of anything in Regent Street or Oxford Street. It occupied much of the area between the main junction, the New Kent Road railway bridge and Rockingham Street. It was as big as many West End stores. Also of importance were Hurlock's, for

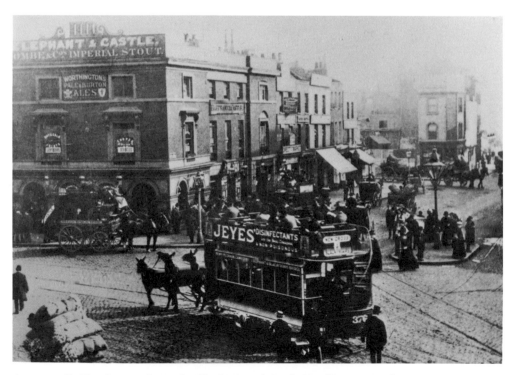

A tram pulled by three mules in the Elephant and Castle Headway, around 1890.

all manner of household goods (glass, china, furniture, shoes, clothes, hats), which was spread over numerous shops in the Walworth Road; the firm of Rabbits, for shoes, on the corner of St George's Road (later Freeman, Hardy and Willis); Upton's, for hats, on the corner of London Road; Waine's, for furniture, in Newington Butts; and Isaac Walton's, a tailor's, which later took over Tarn's main premises. People would go to the Elephant for these shops as they might go today to Walworth Road, the Old Kent Road or Rye Lane, or to the West End itself. It was a focus of commercial life, founded on independent enterprise and popular choice.

Restaurants and pubs also contributed much to the life of the pre-war Elephant. Restaurants included the Silver Grill in New Kent Road, which rather improbably advertised itself as 'two doors away from the Horse Repository', recalling the Victorian undergraduate petition at Cambridge which pleaded for 'the usual joints of recognised animals'; Palmer's in London Road, which specialised in pea soup and eels, and won much custom from performers at the nearby South London Palace ('I must go over and have a basin full at Palmer's,' were the usual departing words of George Chirgwin, a prominent music hall turn); Lockhart's Cocoa Rooms, next to the Elephant and Castle pub; and the Electric Dining Rooms, also in London Road, and run by a celebrated 'coffee house keeper', Tom Garrett. A letter sent to the *South London Press* in 1957 said of dining out at the Elephant decades before: 'Talk about hot trotters, hot saveloys and pease pudding. Life was worth living then.'

As for pubs, the Elephant and Castle itself was only the biggest and most prominent among many. Opposite on the New Kent Road corner was the Rockingham Arms, which sported a Guinness clock in the mid-twentieth century, and next to the Bakerloo Line station on the London Road corner was the Alfred's Head. The Pineapple and the Fishmongers' Arms stood at the end of St George's Road, with the Gibraltar farther along; the Black Prince and the White Hart were in Walworth Road; and the King and Queen was an ancient hostelry in Newington Butts. This is just a small selection from a very large field.

As a place of entertainment, the Elephant could offer just as much. The South London Palace in London Road, a mainstream Victorian music hall, was associated with the likes of Charles Morton ('Father of the Halls'); George Leybourne, the original Champagne Charlie; Gilbert Hastings MacDermott, 'the Great MacDermott'; and Kate Carney. The Elephant and Castle Theatre in New Kent Road, which existed from 1872 to 1928, was a home of melodrama and pantomime. It was then succeeded by the ABC Cinema, later called the Coronet. In the twentieth century, the great newcomer was the Trocadero Cinema, opened in 1930 in New Kent Road. In addition to films, it offered stage-shows, circuses and concerts. Paul Robeson sang there in 1938 and Sir Thomas Beecham brought the Royal Philharmonic Orchestra for Sunday concerts after the Second World War. If your entertainment was boxing, you might go to the King's Hall off London Road, which was a noted boxing venue at one time; otherwise, it served largely as a dance hall for some decades.

Religion at the Elephant centred for a long time on the ancient church of St Mary, Newington, which was the sole parish church of Walworth for hundreds of years. Its churchyard remains at Newington Butts. Among those buried there was Colonel Robert

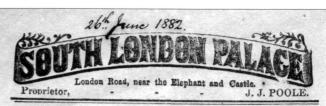

26th June 1882.

SOUTH LONDON PALACE

London Road, near the Elephant and Castle.

Proprietor, - - - J. J. POOLE.

TO-NIGHT.

Re-appearance after severe Indisposition and enthusiastic reception of the Great Comedian,

CHARLES GODFREY

Who will sing Three entirely New Songs, including his last Great Success, "The Flipperty Flop Young Man," at 9.50 every evening.

Return to Town of the universal Favourites,

SISTERS LEAMAR

The Charming Duettists and Dancers. Every Evening at 9 o'clock.

Special re-engagement of the

GREAT MACDERMOTT

In consequence of his great success & big reception. ALL NEW SONGS

Great Burlesque Actor and Comedian

HARRY RICKARDS

After his very successful engagement at Grand Theatre, Leeds.

The old Favourite,

JOLLY JOHN NASH,

Mirthful Comedian and Instrumentalist.

THE LION COMIQUE,

GEORGE LEYBOURNE

BROWN, NEWLAND AND WALLACE,

In a New Sketch entitled **THE LAW COURT**

SISTERS CUTHBERT

Charming Duettists and Dancers. "Happy Eliza," & "Converted Jane."

MISS VESTA TILLEY

World-renowned Impersonator of Male Characters.

THE JUVENILE WONDERS,

MAUD & CHARLEY ROSS

The latter of whom will give his inimitable imitation of CHIRGWIN.

The Programme of Entertainment under the Direction of

MR. HARRY ULPH, UN

The whole under the control of - Mr. J. J. POOLE.

On Monday next, FRESH ARRIVALS.

The programme at the South London Palace 26 June 1882, featuring 'The Great MacDermott'; George Leybourne, *Lion Comique* and the original *Champagne Charlie*; and Vesta Tilley.

Rogers – 'Rogers of the Rangers' – in 1795. He had led a successful unit in North America in the Seven Years' War, on which the American Rangers later modelled themselves. St Mary's church was rebuilt in 1876 in Kennington Park Road, a quarter of a mile away. Near to its old site there arose the Metropolitan Tabernacle in 1859–61, which was a huge Baptist church built for C. H. Spurgeon, 'the prince of preachers'. The Tabernacle was built on part of the site of the Fishmongers' Almshouses, which had stood there from the eighteenth century. The rest of the site was used for Rabbits's premises.

In the late nineteenth and early twentieth centuries, Derby Day was a great occasion at the Elephant, as the procession of vehicles went to and from Epsom. The Elephant was a recognised place to watch it. The Derby Day spectacle was very much in the Elephant's tradition of watching feats, involving horses and pedestrians. Mr Emidy, for example, set off from there in 1844 to drive twenty-eight horses to Greenwich, and many pedestrian feats began there, usually for wagers. Another equine attraction was the London Horse and Carriage Repository in New Kent Road, where many remarkable two-legged characters also made their way until the 1950s.

What a wealth of life and enterprise the old Elephant had! When the present dismal development had been put in place by the 1960s, the vital spark had been extinguished. Hitler had done his worst in the Second World War and had destroyed a great deal of the junction. What is less well known is that much nevertheless remained, and could have been added to instead of being razed and squashed by the megalomaniac redevelopment of the late 1950s and early 1960s. As the old music hall chorus put it, 'Ain't it all a bleedin' shame!'

Newington Butts, looking north from the junction with Kennington Lane, around 1870. The old church of St Mary Newington stands out in the middle distance.

Geographical Scope of the Book

The book discusses the history of a relatively small area in South London, which is centred on the junction of several main roads. Of these, the Portsmouth road, running from London Bridge towards Kennington, Clapham and Kingston, has always been the principal one. Today, it is labelled the A3. In the Middle Ages, another significant route was added. The arrival of the Archbishops of Canterbury at Lambeth at the very end of the twelfth century prompted a flow of traffic from what we now call the Old Kent Road towards Lambeth Palace. Although that traffic could have gone via the Borough and St George's Road, it is clear that there was also already a route to Newington from today's Bricklayers' Arms' junction. In other words, there was a medieval version of the New Kent Road. The present-day New Kent Road was new under an Act of 1751, though the earlier version had been substantial enough to take carts and carriages, as is clearly indicated in the evidence given in a King's Bench Court case in 1447. We shall have to term it the 'Old New Kent Road'. Later, it descended to being a track across the fields of Walworth. It is marked on the map of 1681 as a path running through several field gates, but it is nevertheless given the grand name of 'The King's High Way'. That was the normal medieval name for a main road. This route created the first significant junction at Newington.

A minor junction already existed between the Portsmouth road and the road to Camberwell, which is now Walworth Road. The latter, however, was not much more than a country lane until the second half of the eighteenth century, and its destinations were only small villages and hamlets. Nevertheless, the junction between the Portsmouth and the Camberwell roads had an important result in the layout of the area. The two roads curved round to join at what we now know as the large roundabout. The final stretches of the two roads were parallel. Just south of the junction, they were connected by two short side roads: the one to the north was very short indeed and was at one time known as Short Street; the other to the south defines the southern end of the Elephant and Castle to this day. When it was last a distinct street, it was called Draper Street. So the two main roads, together with the two side roads and the big junction itself, produced two island sites: a small one to the north, which was a thin oblong; and a larger one to the south, which was roughly the shape of a bell. It would seem from old property deeds that these islands were 'the butts of Newington'; in other words, detached pieces of land that were seen as leftovers or 'wastes'. The first mention of any building on this land, on the smaller island in 1641, refers to its site as 'waste grounde'.

These islands were at the heart of the old Elephant and Castle. This book discusses them and also the roads on either side, which came to be called Newington Butts and Walworth Road. I then discuss the history of four further approaches to the junction: St George's Road, London Road, Newington Causeway and New Kent Road. I do not recount the history of these roads in their entirety, but only the parts nearest the junction. A great many subjects belong to that relatively small area. My boundaries are therefore my own, but that would be the case for any writer, because the Elephant and Castle has never been a formal district with defined boundaries.

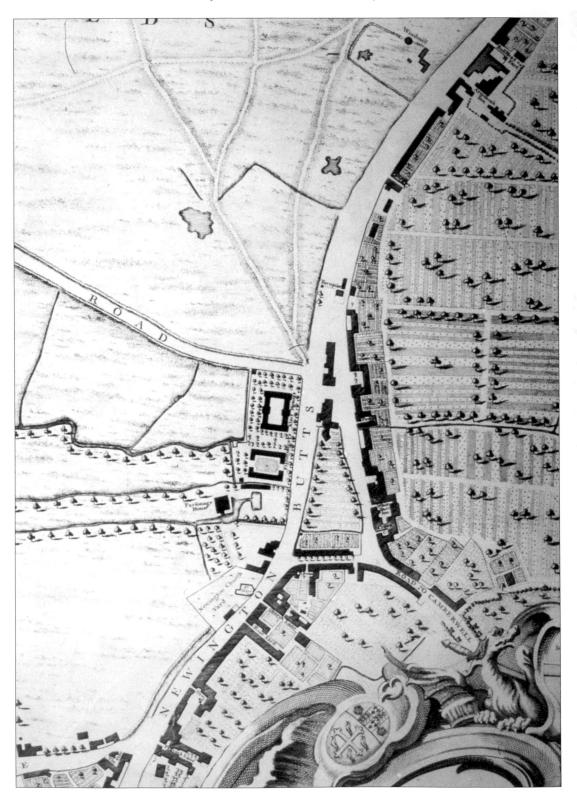

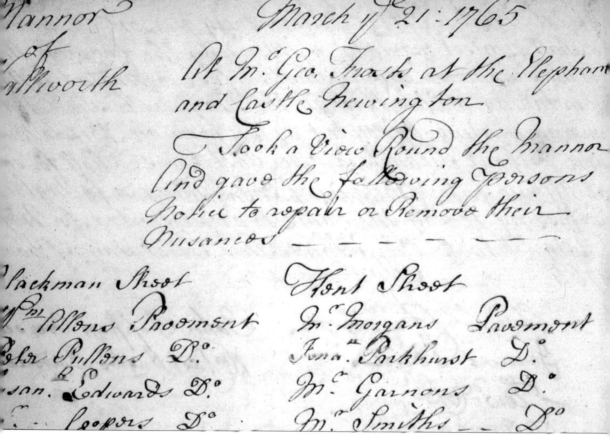

Above: Minutes of Walworth Manor, 1765, including the first mention of the Elephant and Castle pub at Newington.

Opposite page: Part of Rocque's map of London, 1746, showing the two islands at Newington, the Fishmongers' Almshouses and St Mary's church.

The ancient parish of Newington was still a country district in 1750 but rapidly developed in the late eighteenth century as a new and prosperous suburb because of access from London over the new bridges. Building began along the main roads and then in new side roads. The era of initial suburban respectability lasted until around the mid-nineteenth century. The growth of railways and bus services led to an exodus of the better off but also attracted into the district poorer folk from central London. The main streets largely became lined with shops. Tenement blocks appeared in the place of old terraced houses in many parts from the 1880s. By the later Victorian years, the area was very crowded and was blessed with excellent railway, bus and tram services. It was thronged by residents and visitors alike.

The Name of the Place

This book could have been called *Newington: A History*, for that was clearly the name of the district for hundreds of years. Today, we know it by the name of the public house which first appears in recorded history in a minute book of 1765. On 21 March in that year, the Court Leet of the Manor of Walworth met 'at Mr. George Frost's, the Elephant and Castle, Newington'. There is no doubt that the meeting took place at a public house run by George Frost, and that it was situated in the village of Newington, rather as we should refer (to take one famous example) to the Leather Bottle at Cobham in Kent.

Gradually, the name of the pub became more widely used than the name of the village. More or less the same thing happened at Islington, where the Angel gave its name to a district and to an Underground station. People speak of 'going to the Angel' when they wish to refer to the district. I argue below that the Elephant and Castle public house may have been in existence for around ten years before its first written mention, because George Frost paid rent for the site from the Christmas of 1754. But the fifty-one-year lease of the site that had been granted in 1725 clearly states the building was used as a farrier's and was called the White Horse, and some further old deeds are labelled 'White Horse Estate'. There is no doubt, therefore, that the name of the Elephant and Castle first appears in this place as the name of a public house just after the middle of the eighteenth century, and that this public house had previously been a farrier's called the White Horse.

A hundred years later, the particulars printed for the sale in 1859 of the former Newington Workhouse site in Walworth Road stated that the auction of the property would be held at the Elephant and Castle, Newington. Although the public house was a well-known landmark by that time, and had been rebuilt to become a prominent building at a major junction, the compiler of the particulars was still of the opinion that the place was properly called Newington. Thirty years later, however, the new Underground station for the City and South London Railway (later the Northern Line) was given the name of the Elephant and Castle in 1890, rather than the much more ancient one of Newington. By then, the once-separate village of Newington had long since become a suburb of London, and was already an inner suburb.

The modern name of the district is therefore not very old in the context of London's overall history. To the Romans, the Normans, the Tudors and the Stuarts, the name of the Elephant and Castle would have been completely unknown at Newington. But the name did exist elsewhere – in a great many places in the British Isles and in numerous countries overseas – and as a sign it is very ancient indeed. It is important to understand the distinction between the sign in general and its relatively modern introduction to this particular place. The Elephant and Castle at Newington was just one of countless examples all over Europe and much of Asia, but first appears at Newington very late in the long history of the sign.

1

The Elephant and Castle
Public House and its Sign

The Sign of the Elephant and Castle

Hannibal's Elephants

At today's Elephant and Castle there is an office block above the shopping centre, which is called Hannibal House. This is an allusion to the fact that the well-known Carthaginian general led an army against the Romans in the late third century BC, which included a contingent of elephants. Hannibal came from what is now Tunisia in North Africa and led his army through Spain, over the Pyrenees, across southern France, over the Alps and so into Italy itself. He had considerable success at first, but gradually the Romans frustrated him and he was ultimately defeated on his own territory in North Africa. His story has attracted a great deal of attention down the centuries and his connection with elephants has always been widely known. In 1988, the celebrated cricketer, Ian Botham, attempted to recreate Hannibal's journey across the Alps with some circus elephants. Unfortunately, the elephants could not keep up with him. He continued without them, on a walk that was intended to raise money for the treatment of leukaemia.

Hannibal's campaign against the Romans towards the end of the third century BC took place just over 2,200 years ago. Hannibal was using elephants as the ancient equivalent of modern tanks. Elephants were widely used in the ancient world in that role, especially in the Middle East. Numerous rulers had many more elephants than Hannibal and used them more successfully than he did, but he remains the best known example of their use in ancient warfare. Despite this fame, Hannibal is really not so central to the sign of the elephant and castle after all. He was a ruler well to the west of North Africa, and therefore far from the Middle East and India where the military use of elephants began.

It was the Indian elephant that was at the centre of the development of the sign. Hannibal had access for the most part to what are termed African forest elephants that lived in ancient times in parts of North Africa, such as the foothills of the Atlas Mountains and in Eritrea. They are not to be confused with the huge African bush elephants that

lived much farther south and were unknown to Hannibal and his contemporaries. The bones of many of the elephants that Hannibal led against the Romans have been found. They are those of African forest elephants, except for one case of an Indian elephant. There is a difference in size between these two types and a difference in the way they were handled. Indian elephants are much bigger than the African forest type and have traditionally carried passengers on a large platform known in India as a *howdah*. This is, of course, the origin of the 'castle'. It was not the elephantine equivalent of a horse's saddle, because the driver had his own separate perch in front of the *howdah*. In India, the driver is known as a *mahout*. Hannibal's smaller elephants, however, were ridden rather like horses, as may be seen from Carthaginian coins of his time. His elephants were in fact little bigger than horses. The familiar sign of the elephant and castle down the centuries is therefore an Indian elephant carrying a *howdah*.

The Seleucid Empire

Indian elephants were used in warfare long before Hannibal's time. They spread towards the Middle East partly through warfare – elephants could be captured as much as soldiers – and they could also be traded between allies. Just over a century before Hannibal, in the later fourth century BC, Alexander the Great's army overran a vast area between his native Macedonia and India. After his death in 323 BC, his empire split into various successor states. Two of these subsequently dominated the Middle East: Syria, ruled by the Seleucids; and Egypt, run by the Ptolemies. The empires ruled by these dynasties lasted until the Romans conquered their territories. Syria, in particular, had a large military force of elephants. The Syrian king, Seleucus I, made a treaty in 302 BC with the Indian king, Chandragupta, by which he was given 500 Indian elephants in return for the cession of his Indian territories. The following year, Seleucus took 480 of these elephants into the Battle of Ipsus, which he resoundingly won. Seleucus was assassinated in 281 BC but his successor, Antiochus I, continued to use elephants in war. The carving of an elephant and castle overwhelming a Galatian, which is now at the Louvre in Paris, may well mark his victory over the Galatians in 272 BC. The war elephants of a later Syrian king, Antiochus IV, feature in the First Book of Maccabees in the Old Testament Apocrypha. He invaded Judaea in the second century BC and was resisted by Judas Maccabeus. The Louvre carving, the greater part of a century before Hannibal, shows an elephant surmounted by a castellated *howdah* – exactly what the medieval sign of the elephant and castle was trying to reproduce. So the sign that we can see today outside the Elephant and Castle Shopping Centre is much the same as a resident in the Seleucid Empire in the Middle East might have seen nearly 2,300 years ago.

The Abbaye aux Dames at Caen

The sign never died in all that time. It saw the rise and fall of Rome, the rise of the Christian church during the Roman Empire, the onset of what we traditionally term the Dark Ages, the eras of Charlemagne and King Alfred, and then the heyday of the Normans. The most memorable Norman in English history was William the Conqueror, who became King William I of England in 1066. He and his wife, Matilda of Flanders,

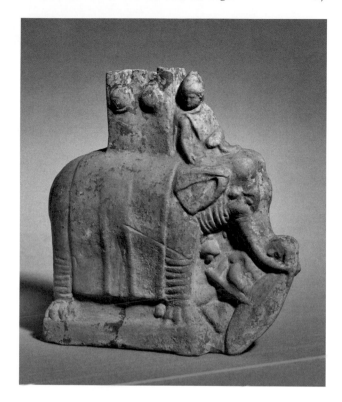

A carving of an elephant and castle from Syria in the early third century BC. (*Musée du Louvre, Paris*)

each founded a monastery in the city of Caen in Normandy. The two churches still stand despite the ravages of the centuries, and particularly the destruction that was visited upon Caen in 1944, during the Battle for Normandy after D-Day. William's church stands in the city centre and is properly called St Stephen's; its popular name is the *Abbaye aux Hommes*. Matilda's stands on a hillside outside the centre. Its formal name is Holy Trinity, but it is usually referred to as the *Abbaye aux Dames*. Its stately eleventh-century interior reveals carvings to the visitor, on the capitals or tops of the great columns. One of the capitals bears the carving of an elephant and castle. This is just under 600 years before the sign appeared at Newington.

Bestiaries

In the following centuries, the sign may be seen more and more frequently. In the type of illuminated manuscript known as a bestiary (a book of beasts, including some imaginary ones), an elephant would always be depicted bearing a *howdah* or castle. A good thirteenth-century example is in the library of Westminster Abbey. It was in the middle of that century, in 1255, that King Louis IX of France gave a real elephant to King Henry III of England. The poor thing ended up in the Tower of London. Some people in London could therefore see a real elephant, but those who drew them for bestiaries often depicted erroneous proportions and anatomy. Many examples have inaccurate feet and legs, or have too small a head or a strangely-shaped trunk; in one fifteenth-century wall painting at Talboys House at Keevil, in Wiltshire, the head and neck look remarkably like those of a duck or a goose.

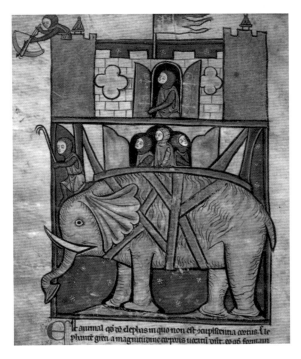

An elephant and castle from a thirteenth-century bestiary held by the library of Westminster Abbey (by kind permission of the Dean and Chapter of Westminster).

Misericords

In medieval cathedrals and monastic churches, the small tip-up seats known as misericords, which provided relief to those who had to stand in the choir stalls for long services, were frequently carved with symbols or scenes. Needless to say, the elephant and castle often appears. Examples may be seen at Gloucester Cathedral, in which the elephants have been carved with horses' feet; in Beverley Minster and St Mary's church at Beverley, in Yorkshire; in St George's chapel at Windsor; in Manchester Cathedral; and in St Katherine's by the Tower in Regent's Park, London. A woodcarving of the sign in a different category is the bench-end at Ripon Cathedral, dating from 1489–94. The sign also appears in tiles at Shulbrede priory, and in sixteenth-century wall paintings at Rye, both in Sussex. An animated use of the sign was a 'pageante of a Olifaunte, with a Castell on his Bakk', to entertain King Henry VII on his visit to Bristol in 1486. All these examples taken together show how widespread the badge was in medieval England.

Civic and Personal Heraldry

By the late Middle Ages, the sign of the elephant and castle had become a standard element in heraldry. It has been described in the language of that world as 'Argent, with a castle on its back proper' [silver, with a castle on its back in its natural colour(s)]. The sign ended up in the civic arms of Dumbarton in Scotland, Coventry in the Midlands of England and Pwllheli in North Wales. In the case of Dumbarton, the sign prompted one local resident, Mr Louis Stott, to set up The Elephant and Castle Information Bureau around forty years ago, and to list fifty-three pubs in Great Britain that bore the name at that time. The sign was adopted by the Cutlers' Company of the City

of London, because of the use of ivory in the handles of cutlery. The Royal African Company of 1672 likewise used the sign due to the ivory trade. In Denmark, the Order of the Elephant (or *Elefontordenen*) long used the sign in its insignia. The gold collar of the order consists of elephants alternating with castles, and the badge includes a *mahout* or driver, who is shown wearing a smart red tunic. In England, the families of Corbet and De Crespigny incorporated the sign in their heraldry. The De Crespignys left Normandy after the Revocation of the Edict of Nantes by Louis XIV in 1685, and eventually built up an estate at Camberwell, a couple of miles south of Newington. To add to this, 'canting heraldry' – heraldic designs chosen for their allusion to the surname or title of the bearer – led to the use of the sign by various families, including the Elphinstones and the Counts of Helphenstein in the German state of Swabia.

A Gurkha Badge

In one interesting use of the badge that originated after our Newington example, an Indian regiment acquired an elephant and a castle separately as battle honours. The 14th Battalion of Coast Sepoys successfully defended the Rock Fort at Amboor in the Carnatic Wars against Hyder Ali in 1767, and was duly awarded the badge of the fort – a typical miniature 'castle' – as an honour. The battalion later became the 10th Madras Infantry. In 1803 it fought in the Battle of Assaye in India under the overall command of Sir Arthur Wellesley, the future first Duke of Wellington. On that occasion it was accorded the honour of an elephant. Subsequently, the two honours were put together in the time-honoured sign. The 10th Madras Infantry was later disbanded, but its possessions were passed down to Princess Mary's Own Gurkha Rifles. These included a piece of plate, known as the Bahadurs' Trophy, which had been presented by four officers. It was illustrated in the *Daily Telegraph* of 1959. Upon the rearrangement of the Gurkha regiments in 1964, the trophy ended up in the possession of the 2nd Battalion, Royal Gurkha Rifles, and is presently held by the adjutant.

The Use of the Sign in London in Stuart and Georgian Times

In Southwark, token coins were issued at an Elephant and Castle tavern at Pickle Herring Stairs in the 1660s and 1670s. Publicans and others issued tokens until the nineteenth century, due to the shortage of change. An Elephant and Castle pub existed in Fenchurch Street in the City from the 1660s, but eventually became known as the Elephant only. Taverns of the full name also existed at Ludgate Hill, on the east side of Belle Sauvage Yard, by 1668, and in High Holborn by 1715. Two bookshops used the sign, for any property could distinguish itself by a sign before the days of street numbering. They were 'the Elephant and Castle without Temple Barre' (outside the present Royal Courts of Justice) as early as the 1620s, and in Cornhill farther east in the city in the 1670s and 1680s. In 1681, a book was published at the Cornhill address, entitled *The Vindication of Slingsby Bethel Esq., one of the Sheriffs of London and Middlesex; against the several Slanders cast upon him Upon the Occasion of his being proposed, for one of the Burgesses to Serve in the late Parliament for the Burrough of Southwark*; it stated that it was 'printed for F. Smith at the Elephant and Castle in Cornhill, 1681'.

In that same era, the elephant and castle sign was used in the arms of various bodies involved in the ivory trade. They included the African Company which was incorporated in 1588 in the time of Queen Elizabeth I; the Cutlers' Company of the City of London (in 1622, replacing an elephant's head crest from 1476); the Company of Royal Adventurers of England and Africa (in 1667); and the Royal African Company (1672). In the same period, there was the well-known literary allusion by John Milton in *Paradise Regained* to 'elephants endorst with towers'.

Pubs called the Elephant and Castle appeared in many more places in London in the half-century or so after 1765. One existed in Mint Street in the Borough, as part of the Suffolk Place Estate; another at Oxford Market; and a third stood opposite St Pancras Workhouse. Two more that existed until recent times had appeared at Vauxhall by the 1760s (now used as a Starbucks coffee shop, but retaining two elephant and castle carvings on the parapets); and in Great Peter Street, Westminster (renamed The Speaker not many years ago). So our case at Newington had many companions, in its own day and for centuries before.

The Myth of a Derivation from Eleanor of Castile

It is an old and erroneous story that Eleanor of Castile gave her name to the Elephant and Castle. Queen Eleanor was the first wife of King Edward I of England (reigned 1272–1307). She married him in 1254. She was the daughter of Fernando III, King of Castile and Leon in northern Spain. She and Edward were crowned in Westminster Abbey in 1274. When she died at Harby in Nottinghamshire in 1290, the grieving King decided to build a series of twelve memorial crosses to mark the resting-places of her cortège to Westminster Abbey, beginning at Lincoln. London boasts Charing Cross, which is a Victorian copy of the medieval original. It stands in the forecourt of the railway station at the western end of the Strand. However, three medieval Eleanor Crosses do survive in reasonable condition at Geddington and Hardingstone, both in Northamptonshire, and at Waltham Holy Cross in Essex. Queen Eleanor's tomb in Westminster Abbey also remains intact. In August 2012, the Queen Eleanor Cycle Ride took place from Harby to Westminster Abbey, and a service was held afterwards in the church of St Martin-in-the-Fields, opposite Charing Cross, to raise money for disadvantaged people in central London.

There are two answers to the allegation that Queen Eleanor's name was the origin of the Elephant and Castle. Firstly, there is the evidence of the sign in general. This book clearly shows that she lived more than 1,500 years after the earliest example of the sign, which I discuss, so she was quite obviously not responsible for the sign in general. An example of the sign from a mere hundred years before her lifetime would be entirely sufficient to disconnect her from its origin. The one in Matilda's church in Caen discussed above is 200 years earlier. But apart from the sign in general, there is the matter of its particular use in the parish of Newington in South London. In this case, as its use appears definitely only in 1765 and is unlikely to have begun more than around ten years before, Queen Eleanor is nearly 500 years too early.

Personal connections with a badge at a particular place do exist. For example, in 1328 Queen Philippa of Hainault, who had lately married King Edward III (reigned 1327–77), made her pilgrimage to the shrine of Our Lady of Walsingham in Norfolk. The pub in the Tuesday Market Place was promptly named the Black Lion in her honour, for the Black Lion was her heraldic badge. The difference in this case was that a particular badge was used by her, and was adopted in a place with which she was personally connected. The Black Lion is a relatively unusual name for a pub, rare in relation to the Elephant and Castle. The hospitable pub at Walsingham has remained under that name to this day.

The story of Queen Eleanor in relation to the Elephant and Castle is therefore a myth. It is wildly anachronistic both in respect of the sign in general and in its specific use at Newington, and she had no connection with the sign or with the place.

Shakespeare's Elephant

It is sometimes stated that Shakespeare's reference in *Twelfth Night* to an inn called the Elephant relates to the Elephant and Castle at Newington. In the play, Antonio tells Sebastian (Act 3, Scene 3, line 39): 'In the south suburbs, at the Elephant / Is best to lodge.' As *Twelfth Night* was first performed in 1601, and the familiar Elephant and Castle is first recorded in 1765, it would be a significant matter if the two were related.

The play dates from the early years of the first Globe Theatre, which stood near the present Park Street in Southwark. William Shakespeare was the owner of a share of 10 per cent in the theatre. He was very familiar with the old town of Southwark, immediately south of London Bridge, and especially with its western part, where the Globe stood. This was within the Bishop of Winchester's manor, which was also known as the Liberty of the Clink. It did not share the restrictions against theatres that applied to the City of London, and it was the City that also controlled three of Southwark's manors east of the one belonging to the Bishop of Winchester. This was the reason why the bishop's manor became a celebrated quarter for theatres in Elizabethan and Jacobean London. Shakespeare very probably lived in the vicinity at some stage, but so far no accepted proof has been found for this. His younger brother, Edmund, however, can be proved to have lived in Hunts Rents off Park Street, and when he died in 1607, he was buried in St Saviour's church, the present Southwark Cathedral.

Within the district that Shakespeare knew well there stood the Elephant on Bankside. This was a long-recorded establishment, which was never called the Elephant and Castle. Shakespeare's reference to 'the south suburbs' was apposite for the vicinity of his principal theatre, for in 1601 they began at the southern end of Old London Bridge and did not extend far down the road. Southwark ran as an urban district a short way beyond St George the Martyr church. Newington was still a village beyond London, separated by fields from Southwark. The Fishmongers' Company built almshouses at Newington in the seventeenth century precisely because the place offered fresh air, country walks, peace and tranquillity in contrast to the great city up the road.

The Site of the Elephant and Castle Public House

We rightly think of the Elephant and Castle pub that existed until 1959 as being the focus of the district. Its site at the northern end of the small island was the defining centre of the place, for its last building there, after 1898, presided over the large junction like a great ocean liner in harbour. But when that site first appeared in the vestry minutes of the parish of St Mary, Newington, in 1641, it was described as waste ground. The islands were empty. The site stood at the boundary of the parish with that of St George the Martyr, Southwark, and it also stood at the boundary of Walworth Manor. The focus of the village of Newington lay just a little to the south, along the road we now call Newington Butts, but usually known as High Street in past centuries. The village was very small in the seventeenth and eighteenth centuries. To its north lay St George's Fields, a very large and somewhat damp open space. St George's Road ran through its southern side, almost bereft of buildings. And there was no New Kent Road until the 1750s. Buildings lined the south side of Newington Butts or High Street, and the eastern side of Walworth Road. The church of St Mary, Newington, stood on the north side of Newington Butts, where its churchyard survives today.

The site of the future Elephant and Castle pub appears in the Newington vestry minutes on 8 June, 1641:

> Md. [Memorandum = let it be remembered] the viijth [8th] daie of June 1641 It is agreed by the vestrymen with the Consent of the right worshipfull the Deane and Chapiter of Canterburie and the Stewards of Our Courte Baron and of the Homage that John Flaxman Smith shall have libertie to builde a workshop upon the waste grounde against the Fishmongers Almeshouses on the place appointed and to hold the same for soe long time as the lordes of this mannour and the Homage shall thincke Convenient, Paying therefore four shillings yearlie to the use of the Poore of this parish.

In other words, John Flaxman, a smith or farrier, was allowed to build a workshop on the waste land for the yearly rent of 4 shillings [20p], and this money was to go towards the relief of the local poor.

This decision was made just before the English Civil War began in 1642. In the following years, during Oliver Cromwell's Commonwealth, Crown and Church estates were sold off or leased. The properties were generally recovered after King Charles II's Restoration in 1660. The Dean and Chapter of Canterbury re-emerged and duly recovered their manor in Walworth. The Newington Vestry 'agreed and ordered that Mr. William Mason and Thomas Winter Churchwardens shall tacke the best case they can in gettinge of A Confermation of the Ground given by Robert Render unto the use of the poore upon parte of which ground the Whithorse is built upon'. The Dean and Chapter's manorial court duly ruled that the grant of the land by Robert Render in 1658 could be confirmed. He must have been a Cromwellian intruder, but as his grant was in favour of the relief of the local poor, it was evidently seen as unexceptional.

On 21 August 1673, the Vestry ordered that Thomas Bowers should have a thirty-one-year lease of John Flaxman's old site from Michaelmas Day [29 September

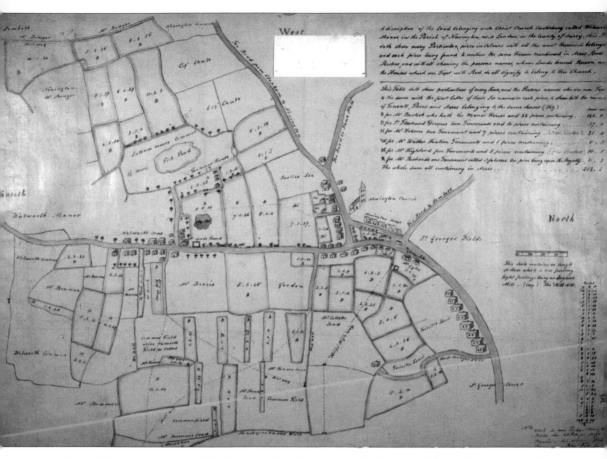

Map of Walworth in 1681. The junction that became the Elephant and Castle is clearly much busier than the hamlet of Walworth to the south.

1673] for £6 a year. In the end, the lease that was granted was dated 24 August 1674, and allowed fifty-one years from Michaelmas Day in 1674, with the rent still at £6 a year. Thomas Bowers, described as a gardener, was to have 'All that messuage or tenement called or known by the sign of the White Horse' and the property was said to be abutting on the highway against the Fishmongers' Almshouses. 'Against' in this case meant 'opposite'. The deed is labelled on the dorse [or back], White Horse Estate.

Now an oddity here – and a difficulty – is that the property next door, farther south on the same small island, was leased to Thomas Pinckard of St Mary Newington, farrier, for fifty-one years at £1 10s 0d [£1.50] a year, in a deed dated 29 September 1676. Pinckard's property included a stable and a hayloft. Did he duly become a farrier there and, if so, were there two farriers side by side? It was certainly the case that as the fifty-one-year lease given to Thomas Bowers was coming to its end, the Rector of Newington and the parish's trustees granted a new fifty-one-year lease to run from 29 September 1725, still at £6 a year. The new lessee was William Benskin of St Mary Newington, a farrier, and the property was still called the White Horse.

It was during the lease of 1725 that a significant change came to the site. We have already noted that on 21 March 1765, the manorial court was held 'At Mr. George Frost's at the Elephant and Castle, Newington'. The site which had been a farrier's called the White Horse was now a pub called the Elephant and Castle. George Frost's first connection with the site was when he paid the rent of £3, which was due at the Christmas of 1754. He first appears at a Newington Vestry meeting on 15 April 1755, as a manorial juror on 24 October 1758, and as the manorial constable for Walworth on 30 October 1760. It may be the case that George Frost was originally a farrier and then foresaw more profit as a publican upon the opening of New Kent Road. But there is no listing of a George Frost at Newington in that period in the records of the Farriers' Company. It is conceivable that the farrier's became a pub before Frost's tenure, perhaps still under the name of the White Horse. But this seems highly unlikely in the days of William Benskin, who was undoubtedly a farrier by trade, and dubious under any lessee before New Kent Road was opened. We can only say that the Elephant and Castle pub existed without doubt from 1765 and may have been founded under that name by George Frost as early as 1754.

The Elephant and Castle Public House from 1765

George Frost, the first licensee of the pub in 1765, certainly appeared on numerous occasions in the records of Walworth Manor and of St Mary Newington Vestry, but he made no appearance in the records of the Farriers' Company and was not included among the apprentices of the Cutlers' Company. There is no evidence to connect him with the shoeing of horses, the cutlery trade or with another pub elsewhere before he arrived at Newington. The sudden appearance of the ancient sign under his proprietorship cannot be explained by his career. As with the vast majority of pub names, the choice in this case was probably a random one. The new pub could just as easily have been named the Red Lion, the Six Bells or the Anchor, or it could have kept the name of the White Horse, which applied to the farrier's workshop.

The story of the renting of the site of the Elephant and Castle pub ranges from the humble circumstances of 1641 up to the lease of the expensive imperial pile of 1898. It was expensive in terms of the new rent and in the amount that the lessee had to spend in a new building; and it was imperial in the size and grandeur of the building, and in the way it dominated the junction. The rent payable in successive leases grew steadily – slowly at first but more obviously in the nineteenth century, when the area became a busy and profitable commercial centre.

The lease taken over by George Frost lasted for fifty-one years from 29 September 1725. The annual rent was only £6. So a new lease was drawn up in 1776, in favour of Christopher Barrett. Its terms were much more demanding. It was to last for just twenty-one years and the rent for the whole of the small island (and not just the pub) was £100 a year. At the next renewal, in 1797, a further twenty-one-year lease of the whole estate cost £194 a year. The amount demanded had almost doubled. A more drastic and important change came in 1818. An auction was held for thirty-one-year

leases for four lots. The then licensee, Jane Fisher, was awarded lots 1 and 2. Lot 1 was the pub, now at the stupendous rent of £405 a year. Lot 2 was a building immediately south of the pub. It was called the House of God, which was used as a chapel by the followers of Joanna Southcott (1750–1814). She was the well-known prophetess from Devon, who made numerous predictions, which were published in *The Strange Effects of Faith* (1801) and in many further booklets. Early in 1814, the most extraordinary prediction claimed that she was going to give birth to a son, Shiloh, 'by the power of the Most High'. However, she died in November that year. The chapel in Newington Butts had been founded in 1805 by a wealthy patron of Southcott, Elias Carpenter. He was a papermaker who had run Neckinger Mill in Bermondsey and who had opened a chapel for her there in 1803. The new chapel was intended to replace it as her headquarters. Later in 1805, however, he separated from Southcott's movement and ran the chapel at the Elephant independently. Initially, the chapel remained by the pub, but in 1818 Carpenter removed it to Amelia Street, off Walworth Road, where it was still active in 1840.

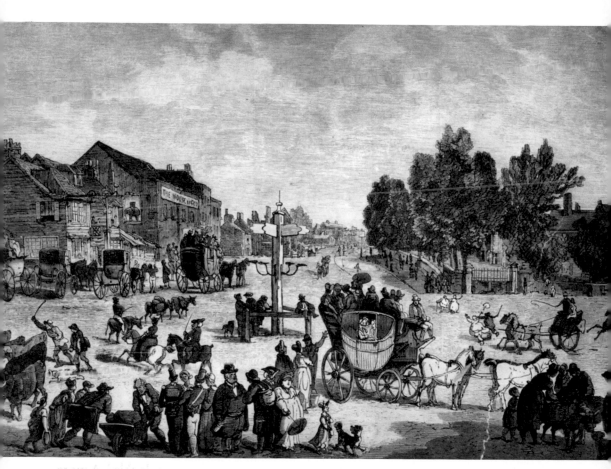

Thomas Rowlandson's view of the junction. The sign of the pub can clearly be seen on the left. The Fishmongers' Almshouses stand behind the trees on the right.

Mrs Fisher and the lessees of lots 3 and 4 were required to rebuild or improve their properties. Mrs Fisher duly rebuilt the pub. The old rustic building was replaced by a grand Georgian one. This was an oblong with fine five-bay façades to Newington Butts and Walworth Road, of which the middle three bays were recessed. The bay farthest from the junction was given a particular type of Regency window, in which the arched hole is divided vertically into a wide central light, with one horizontal bar, flanked by undivided narrow strips. The accounts of the Trustees of the Elephant and Castle Copyhold Estate record a payment on 16 December 1819 of £110 9s 0d [£110.45] to a 'Mr. Medland, Surveyor'. He was evidently James Medland (died 1823), who practised in Newington Butts. Given the size of the payment, he may well have designed the new pub and acted as the clerk of works for the rebuilding of the estate. He undoubtedly designed (in 1805) Nos 17–25 Clapham Road, which still survive. They form one composition, higher at each end, but without details, which suggest a clear link with the pub.

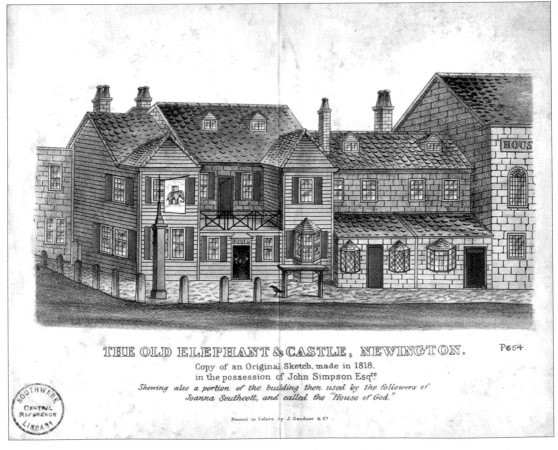

THE OLD ELEPHANT & CASTLE, NEWINGTON. P654.

Copy of an Original Sketch, made in 1818,
in the possession of John Simpson Esqre.
Shewing also a portion of the building then used by the followers of
Joanna Southcott, and called the "House of God."

Printed in Colors by J. Gardner & Co

Print of the Elephant and Castle pub in 1818, just before its rebuilding. The House of God on the right had briefly been Joanna Southcott's chapel.

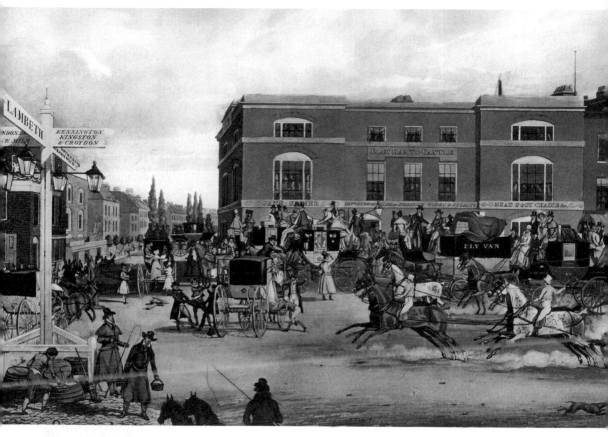

James Pollard's view of the Georgian Elephant and Castle pub, 1826, and showing a traffic jam in Newington Butts. (*Image reproduced by kind permission of Lambeth Archives Department*)

It was Mrs Fisher's pub that featured in James Pollard's well-known view of 1826. It lasted for just under eighty years. A new twenty-one-year lease was granted in 1849, under which the sum of £736 a year was paid for the pub out of a total for the estate of £1,239. A new lease of twenty-and-three-quarter years in 1870 raised these figures to £850 and £1,378.

A long article in 1837 suggested that the life of the pub in the days of Jane Fisher centred on its coffee room, 'in which assemble the elite of the neighbourhood'. The constant comings and goings of the place were emphasised. Thomas Taylor, who ran the pub subsequently, called it a 'Commercial Tavern and Hotel'. In 1851, he declared that he was 'ever anxious to sustain the high character of his House', and published a long list of spirits, fortified and regular wines, stouts and ales, with a note about 'foreign cigars of the first quality'. The prices of wines and ales were all quoted in dozens of bottles, and so the stock of the place must have been huge. Theophilus Haythorn Read, the proprietor in 1870, who called the pub a 'Family Wine and Spirit Establishment', stressed his 'wholesale family trade'. A 'large private sample room' was set apart in the building, where wines could be selected.

The landlords throughout all the transactions over leases had been the Trustees of the Copyhold Charity Estates of the parish of St Mary, Newington. In the 1890s, the Elephant and Castle Estate (which consisted of the entire smaller island) ceased to be copyhold (that is, held by copy of the manorial roll); it was 'enfranchised' to become a freehold. Also, there was a long-running proposal to alter the site to be leased. This entailed temporary leasing arrangements between 1891 and 1897.

The Vestry and the London County Council tried to gain a slither of land from the island estate to widen the north end of Walworth Road, but were reluctant (to say the least) to pay for it. Correspondence passed between the parties over several years, with aspiration on the Vestry's part but no willingness to pay. In the end, the trustees decided to seek tenders for a new eighty-year lease from Lady Day (25 March), 1897, which would require 'a thoroughly good and substantial building or buildings, with stone fronts or fronts of red-brick, with Portland stone dressings'. The building was to be complete by Lady Day in 1898. The trustees rightly judged that the time had come to charge more rent for a significantly grander building. The new lease was taken by Algernon Meekins, and it was he who paid the substantial cost of the rebuilding.

The result fully lived up to the Trustees' requirements. John Farrer, the architect of the grandest building ever occupied by the Elephant and Castle Public House, was born in 1843 at Sleagill, Westmoreland. His family worked as yeoman farmers, master carpenters and builders. He came to London in about 1865 to be articled to James Wesley Reed, an architect and surveyor of Hornsey Rise. Hornsey was to be the principal setting of his work. In 1875, he became the Principal Assistant to Edwin Arthur Brassey Crockett, and two years later he set up his own practice at Finsbury Pavement, which was transferred in 1899 to Coleman Street within the City of London. John Farrer died in 1930. His design of the Elephant and Castle Hotel dates from his heyday.

The banding of stone and red-brick may be seen in his town centre shopping terraces in Muswell Hill and Crouch End. Another pub of his design, the Three Compasses in Hornsey High Street, built in 1895/96, survives. His great pub presided for sixty years over the Elephant and Castle junction, taller than anything around it and filling the entire width of the island site between Newington Butts and Walworth Road. It was indeed the proud flagship of the district which bore its name.

This impressive pub was closed on 8 March 1959, when the landlord, Tom Thurlow, a former police sergeant, rang 'time' for the last time. Never again would the pub that gave its name to the junction be able to rule over it as the most prominent building on the central site. Farrer's pub had been damaged in the Second World War and lacked parts of its roofline thereafter. It had also lost much of its former trade, for it had once been busy with the meetings of the Freemasons, the Oddfellows, the Royal Antediluvian Order of Buffaloes and the Good Templars. Farrer's building offered forty rooms; in the twentieth century the pub gradually retreated from parts of its island site, letting them as shops and offices. Its glories had faded due to the depredations of war and the threat of redevelopment, which cast a dark cloud over the district after 1945. The district was blighted and the pub suffered along with the rest. The statue of the elephant and castle from the pub's roof was preserved and now stands outside the shopping centre.

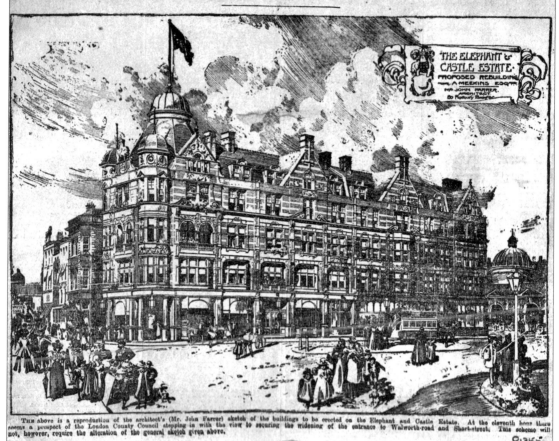

THE NEW ELEPHANT AND CASTLE.

John Farrer's design for the grand Elephant and Castle Hotel, 1898, which then stood until 1959.

The present pub called the Elephant and Castle was opened in a new building on the corner of New Kent Road and Newington Causeway in 1966. It stands on the equivalent site to that of the old Rockingham Arms before the London County's Council's redevelopment. At least it keeps the name of a living pub and still watches over the junction.

2

The Parish and Church of St Mary, Newington

Newington and Walworth

The village whose extent we now label the Elephant and Castle had been called Newington since at least the thirteenth century: a new settlement within the ancient district of Walworth. The parish church has certainly been known from the early thirteenth century as the church of St Mary, Newington. Its parish corresponded with the Manor of Walworth – east and west of the Walworth Road – plus the big triangle of land bounded by Newington Causeway, Kent Street (the present Tabard Street) and New Kent Road.

Walworth has an entry in Domesday Book, which states that the manor belonged to the monks of Canterbury Cathedral Priory (properly known in the Middle Ages as the Prior and Convent of Canterbury). At the Reformation, when the monastery was dissolved, the Prior and Convent were replaced by the Dean and Chapter. There is no mention of Newington in Domesday Book.

Canterbury's manor in 1086 included a church. There has been speculation that this may have stood near the manor house in what became Manor Place, some way south of the modern Elephant and Castle. Newington is clearly a subsidiary name to that of Walworth, and therefore subsequent in date, but they are both Old English in origin and so the names themselves do not point to an obvious date for Newington. Walworth itself does relate to an early time in the English settlements, perhaps to the sixth or seventh centuries, when a Celtic settlement would still stand out amid the English newcomers. Its earlier version, *wealawyrd*, means 'the farm or settlement of the wealas'. The latter word in turn was used by the English settlers to refer to the Celts. It literally means stranger or foreigner (in other words, anyone of non-Germanic origin) and is the same word that appears in Wales and Cornwall, Celtic parts of the British Isles. But the first appearance of Walworth in documents has traditionally been assigned to the early eleventh century, in King Aethelraed II's reign, and later documents have been held to relate to his successor, King Edmund II (Edmund Ironside). More recently, a reinterpretation has suggested that the first document refers instead to King Edmund I in the mid-tenth century. Domesday Book was primarily concerned with

landholdings and their value for purposes of taxation. It was therefore reasonable to expect that Walworth would appear as the manorial landholding, even if Newington was already in existence. But it would seem strange in those circumstances that the church did not continue to be identified as Walworth's rather than Newington's.

The name of Newington appears in various places in England. Two instances in Kent and one in Oxfordshire both appear in Domesday Book, and Stoke Newington in north London is also found there, simply as Neutone. In our case, it must have been the pull of the main road and its junctions that led to a busier and therefore larger new settlement than the one to the south. The arrival of the Archbishop of Canterbury at Lambeth at the very end of the twelfth century was the most obvious reason for increased traffic at the site, and that would tally with the first mention of the place and its church in the early thirteenth century. The first vestry minute book of the parish, in Elizabethan times, mentions evidence that was claimed for a thirteenth-century foundation. It gives details of heraldic stained glass that had been new in 1493–96 'for the knowledge of the foundation of the Churche of Newington'. One of the coats of arms is linked with Geoffrey de Lucy, Bishop of Winchester in 1189–1204. None of this proves a foundation on a new site in the early 1200s, but it makes it the most plausible version on the balance of probabilities. Archaeology may one day date the origin of Newington village and maybe the site of Walworth's manor house too.

Newington and Newington Butts

Today, everyone uses the more ancient name of Walworth, and Newington lives on only in the title of the library in the Walworth Road and in the two street names, Newington Butts and Newington Causeway. Newington Butts was once called High Street. 'Butts' was a late addition to the name of the village itself. Inevitably, it has been ascribed to the presence of archery butts due to Tudor ordinances, but the obvious response is to ask why the word did not appear everywhere in that case. The word, butt, is defined in the *Oxford English Dictionary* as 'a small piece of ground disjoined in whatever manner from the adjoining lands'.

Very often, it appears in the plural. At Newington, there were the two islands at the heart of the junction, which were not only 'disjoined … from the adjoining lands', but were small and ranked as 'wastes' until at least the seventeenth century. They were also on the very edge of the manor of Walworth, and it is frequently the case that 'wastes of the manor' are found at its boundaries, where they run alongside another manor or parish. The title deeds relating to the Elizabethan theatre (see article below) refer specifically to the field called Lurklane being opposite the 'Butts of Newington'. It seems to be clear that the term was being applied to the two islands opposite. Butts appears in many places elsewhere. Lambeth Butts was the name for a part of what is now Black Prince Road, off the Albert Embankment.

Church and Parish

Down to the mid-nineteenth century, an ecclesiastical parish was also a civil parish, in other words, a district whose affairs were run by what we now call a council. In the nineteenth century, the ecclesiastical and the civil parishes diverged. They were

formally separated from 1 January 1856, and then existed in parallel until 1900. The church building remained at the Elephant until 1876, when it was rebuilt in Kennington Park Road, close to the site of the later Kennington Underground station. The civil parish was run from 1865 from a building called Newington Vestry Hall, on the corner of Walworth Road and Wansey Street. This building became the Town Hall of the new Metropolitan Borough of Southwark in 1900, which incorporated the civil parish of Newington. When Southwark was merged with the Boroughs of Bermondsey and Camberwell in 1965, the Walworth Road building ceased to be the Town Hall. It remained in municipal ownership, and housed the Cuming Museum on the ground floor until a serious fire in March 2013.

The Church Building
The last St Mary's church to stand in Newington Butts was demolished in 1876, following the opening of a replacement a quarter of a mile to the south. The new church was a large Gothic building, designed by James Fowler of Louth, whereas the old structure was by then an unfashionable Classical pile. It had been built only in 1791–93 to the designs of Francis Hurlbatt, a local architect. Its west front featured a row of columns supporting a pediment, rather like Spurgeon's Tabernacle, but whereas such a feature was deliberately chosen by Spurgeon for his Baptist church in the late 1850s, it was profoundly out of fashion for an Anglican one by the 1870s. You can still see big Classical churches of the type at Waterloo (St John's) and at Kennington (St Mark's), both built a generation after St Mary's. In the Newington case, the columns were placed at the west end, facing into the churchyard, whereas the view from Newington Butts was of the apsidal east end. The latter jutted out into the street, for the 1721 and 1793 churches in turn had extended farther east than their predecessors. Pictures of the church show it with box pews (tall pews with doors to the aisles) and with galleries, which would have been normal for a building of 1793 and for a few decades afterwards.

Hurlbatt's church had replaced an earlier Georgian building dating from 1720/21. It had been opened on 26 March 1721. The parish had tried, without success, to have St Mary's made one of the fifty new churches under the Act of 1711. The church of 1721 and its two successors each lasted around seventy years. So there was only a limited accumulation of the memorials and fittings that such an ancient foundation might have been expected to possess. The pre-1720 building had been given a north aisle in around 1600 by a prominent local worthy, Sir Hugh Brawne, who had died in 1614. His memorial had been a prominent one in the usual Jacobean manner.

The Georgian church of 1791–93 was deeply unfashionable by the 1860s, when Gothic was the normal style for churches. The *Illustrated London News* commented on 9 November 1871 that it was 'not in itself a desirable building'. T. Francis Bumpus, the prolific writer on churches, referred to it as 'a hideous eighteenth century monster'. Henry Syer Cuming, the distinguished local historian, was even more disdainful. He referred to the old St Mary's as 'the hideous erection which was an Eye-sore in the Parish until September 1876, when its materials were sold'. So much did he detest it, that its closure and supersession by the new church in May 1876 were insufficient

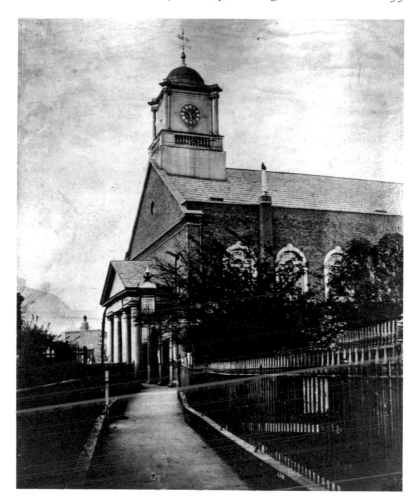

Old St Mary
Newington
church, 1866, a
few years before
its demolition
and removal.

to satisfy him. It had to be demolished and its materials sold to bring him peace. He
stated, interestingly, that 'the Parishioners were greatly grieved that the new church was
not erected within the bounds of the ancient Church-yard'. It would indeed have been
agreeable if the new church had been built there as the focus of a discernible historic
quarter; after all, Newington Butts had been the High Street of Newington village. But
the ancient rectory was also removed in 1870, and the schools stood farther north,
behind shops, and so it would have struggled to be an attractive focus on the model,
say, of St Mary's, Walthamstow. Nevertheless, it would have had a grander setting than
where it was put.

A new Rector of Newington had been appointed in 1869, after the fifty-seven-year
tenure of Arthur Cyril Onslow. No doubt this succession brought about a sudden burst
of energy and change. The new rector was William Dalrymple Maclagan, who was to
serve in Newington for just six years. He then took up the important post of Vicar of
Kensington, before becoming Bishop of Lichfield and finally, in 1891, being appointed
Archbishop of York, in which exalted office he served until 1909. In 1869, he was

clearly a new broom in Newington. So we find a report in the *Building News* for 12 November 1869 that the box pews of St Mary's were being replaced by open benches. This was a typical High Victorian alteration to a Georgian church interior. In addition, the *Church Times* of 10 December reported that the *SPCK Hymnal* was being replaced by *Hymns Ancient and Modern*; the three-decker pulpit had been reduced in height and had been removed to the south side; and the free seats had been removed from the centre of the middle aisle. In the days when seats in the box pews were rented, free seats were usually provided in the middle aisle for the poor. Finally, Holy Communion was now celebrated weekly. By contrast, a notice in 1861 advertised the service only on the first Sunday of each month and on special occasions.

Yet within a couple of years there were preparations for a completely new church. Subscriptions were being collected in 1871; the published list includes the sum of £100 from Mr Tarn, who owned the great store in Newington Causeway. This was not merely prompted by ecclesiastical concerns, but also by municipal ones, for the narrowing of the main road caused by the protrusion of the church was one that the Victorian public authorities hankered to remove. The *London Journal* remarked on 19 November 1876 that it 'rendered the roadway dangerous to pedestrians and difficult for those drivers who were not very proficient in the art of avoiding collisions'. In 1872, an Act of Parliament sought to solve the matter. The Metropolitan Board of Works, which was the prime mover in the case, was going to pay the sum of £5,000 for the existing church that was to be demolished. A new church was intended to be built on a site a quarter of a mile south in Kennington Park Road, but in addition a new mission church of St Gabriel was to be built on the far (or northern) side of the churchyard and would house the congregation before the new St Mary's was ready. St Gabriel's was built in 1873/74 (see below). The foundation stone of the new St Mary's was laid on 29 July 1874, by Lord Hatherley, the Lord Chancellor. It was consecrated by the Bishop of London on 1 May 1876. The last service in the old church had taken place the day before.

The new church of 1876 was a substantial aisled building, which was later provided with a tower. The intended spire was never built. The church had facings of Kentish ragstone, with dressings of Bath stone and Ancaster stone. The church was 100 feet long, and had hammer-beam roofs in the nave and chancel. It was much embellished in subsequent years. In 1877, William Tarn donated an organ in memory of his father, who had died in 1869. Bombing on 10 May 1941 removed all but the tower and the old west front. A smaller church in modern style by A. Llewellyn-Smith was built behind these survivals and was opened in 1958. James Fowler's Early English or thirteenth-century design was a clear statement that St Mary's represented a proud and significant parish, in the manner of St Giles's church at Camberwell, built in 1842–44. St Mary's was built in a rare corner of the ancient parish that was still middle-class and prosperous in 1876. Henry Syer Cuming, who was to bequeath his family's considerable historical collections to the Metropolitan Borough of Southwark in 1902, lived at No. 63 Kennington Park Road (St Mary's Rectory was No. 59). The Newington side of Kennington Park Road lacked shops but retained first-class houses of late Georgian date, and still does.

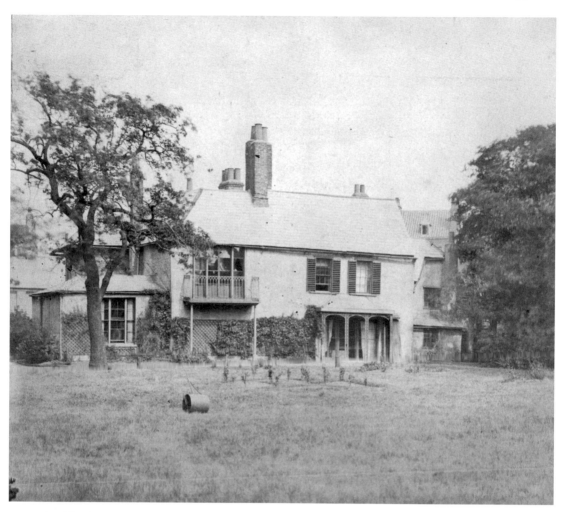

The ancient St Mary Newington rectory, around 1870.

The Rectors, Rectory House, the Advowson and Glebe

In addition to the future Archbishop Maclagan, one other rector served as a bishop. He was Samuel Horsley, rector from 1750 to 1793, who was also the Bishop of St Asaph in Wales. In the Middle Ages, the right to appoint the rectors (the advowson) was in the hands of the Archbishops of Canterbury. It passed to the Crown in 1546, and was then granted the following year to the Bishop of Worcester.

The ancient house of the Rectors of Newington stood immediately north of the churchyard. On Rocque's map of 1746 it stands out clearly as the only building between the church and the Fishmongers' Almshouses. It is often stated that it was moated. In fact, it was flanked by drainage ditches, which were connected to the 'River Tigris'.

The glebe (or land belonging to the benefice of St Mary Newington as an endowment) lay to the north and west of the churchyard. Part of it was used to build the new St Mary Newington Schools in 1820.

St Mary's Churchyard

St Mary Newington churchyard in Newington Butts was laid out as a public garden in 1878. In view of this improvement, plus the building of the large clock tower in 1877/78 and of the new St Gabriel's Mission church, the scene remained distinctly ecclesiastical. The tower and the mission church have long since gone, but the churchyard is still a prominent feature of today's Elephant and Castle. It ranks as a small public park and has none of the standing tombstones that one would expect to see in a country churchyard. For many centuries, however – from the early thirteenth century until 1854 – it did serve as the main or only burial ground of the entire parish of St Mary, Newington, surrounding the parish church itself. A memorial stone may be seen where the church once stood, near the old main gate. It was agreeable to see the old railings repaired a few years ago, but dismal to see the introduction of peculiar ornaments within the churchyard. The burial land ought to have been made distinct from the adjoining open space. It would have been agreeable to see the entire burial ground surrounded by the same railings, but that would have needed a benefactor.

Hob Nob

Five small properties stood in a group on the Newington Butts frontage of the churchyard, towards the end nearest to Churchyard Row, detached from the church and from any further buildings. They were collectively known as Hob Nob. This is an old expression whose basic meaning is to be friendly, especially when drinking, but it could mean just to converse with someone. Maybe in this case the isolated group in the High Street was looked upon as a group of 'friends'.

The Clock Tower

After the church in Newington Butts had been demolished in 1876, the churchyard came to be dominated by the clock tower, which was built in 1877/78 on part of the site of the old church. It was donated by Robert Stephen Faulconer, a former churchwarden of the parish who practised as a chemist in Walworth Road. It was 90 feet tall and 14 feet square at the base. The lowest 5 feet were built of Portland stone, and the rest was in brick, faced with Bath stone. The tower was designed by Messrs Jarvis & Son, the well-known local firm of architects, and it was built by Messrs Colls & Sons, of Camberwell.

The style was Gothic, with most of the detail applied to the base and to the upper part of the square tower, where the illuminated clock faces were placed in a wider stage. Each clock face was surmounted by a tall gable, with pinnacled corner turrets flanking them. Above the clock stage was a miniature steeple, consisting of a circular turret with narrow, open arches, each with a gable above, and then a short spire with a vane at the top. This is similar to the design of the clock tower of the Houses of Parliament, which the world calls 'Big Ben' after its famous bell; since Her Majesty's Diamond Jubilee, it has been properly called the Elizabeth Tower. It shares with Newington's former tower the wider stage for the clock faces, the short spire above and of course the Gothic style. Newington's equivalent of 'Big Ben' was a 9-cwt bell to mark the hours, with four companions to ring the quarterly Westminster chimes. The clock and bells were made by Messrs Gillett & Blend, of Croydon.

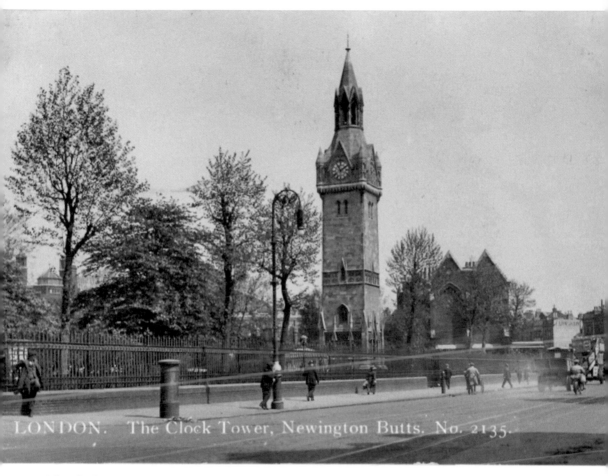

LONDON. The Clock Tower, Newington Butts. No. 2135.

The Clock Tower, Newington Butts, built in 1877/78 on part of the site of old St Mary's.

Two polished red granite panels were placed on either side of the doorway at the base. They were inscribed with some notes on the tower itself and on the history of St Mary's church. These panels may be seen in the churchyard today.

St Gabriel's Church

Despite building the new church of St Mary, Newington, just a quarter of a mile away, another church was also built on the north side of the old churchyard at the Elephant. It was technically a chapel of ease in the parish of St Mary, but it was usually called a mission church. It was dedicated to St Gabriel – in other words, the Archangel Gabriel, who made the Annunciation to Mary. It is an uncommon dedication for an English church. There is one in Pimlico, and before the Great Fire of London there was a medieval example in Fenchurch Street in the City of London. J. Edward K. Cutts was the architect, who designed a building with single-light lancet windows throughout. It had a nave with low aisles, a bellcote placed on its eastern gable and a porch at the west

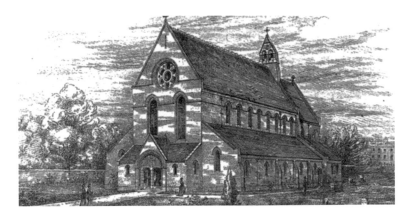

An engraving of St Gabriel's church, Newington Butts, at the time of its building.

end. There was no tower. The short chancel had a south transept and what amounted to a north aisle, which was used to house the organ, and choir and clergy vestries.

The church was probably never needed, given the proximity of the new St Mary's and of St Matthew's in New Kent Road. In Victorian times, however, church building was relatively inexpensive and there were many Victorians who were willing to donate money to the cause, and to support a new building. So the foundation stone of St Gabriel's was laid on 29 September 1873, and it was consecrated on 9 May 1874. For a couple of years, therefore, two churches stood in the same churchyard. In building St Gabriel's, it was necessary to exhume some bodies from the site, and they were then interred in a number of vaults which were said to have 'remained almost empty when the churchyard was closed for interments' (in 1854). These vaults were uncovered in 2012 when work began on the new leisure centre on an adjoining site.

It may well be that subsidence was a threat due to vaults and old graves, for in 1920 the church floor began to give way, and St Gabriel's fell into a sad decline. It was not until 1935, however, that the Order-in-Council authorising its demolition was issued. It was closed on 12 March in that year, and it was demolished in 1937. One small window was to be given to the Revd G. Halsey, Rector of Somerleyton in Suffolk, to commemorate his ministry at St Gabriel's.

Rogers of the Rangers

One of the thousands of people buried in St Mary's churchyard was Lt-Col. Robert Rogers (1731–95), known as 'Rogers of the Rangers'. He was a celebrated soldier in North America during the Seven Years' War of 1756–63, which is usually called the French and Indian War by the Americans. He formed and commanded a force of 'rangers', which is regarded today as the forerunner of the American Rangers. Both he and the force acquired a considerable reputation, which keeps alive his fame in the USA. After he died on 18 May 1795, he was buried in the churchyard of St Mary, Newington, two days later. The entry in the burial register mistakenly calls him Richard Rogers.

In his later years he had been a debtor living in the Rules of the King's Bench Prison. The prison itself stood just north of Borough Road, on the same alignment as the present Scovell Road Estate and on that of Queen's Buildings previously. Debtors'

prisons were very unlike the normal criminal prisons that come to the minds of most people. In the case of the King's Bench, a substantial number of its 'prisoners' were allowed to live in a defined area of the Borough, stretching a good way from the prison walls. This was on the western side of Borough High Street and north of Borough Road, which fell within the parish of St George the Martyr, Southwark. Rogers, however, managed to live on the eastern side of the main road, a little north of today's Harper Road, technically outside the Rules, although it was directly opposite one end of the prison, and this was perhaps the reason for the arrangement being tolerated. The eastern side of the main road was part of the parish of St Mary, Newington, and that is why Rogers was buried in the churchyard at the Elephant and Castle rather than in St George the Martyr's churchyard a little way north of the prison.

Georgian debtors very often took to drink, and that was the case with Rogers in the King's Bench. So his Southwark days were a sad sequel to his heroic heyday in North America. His unmarked grave is in great contrast to the expectations of occasional American enquirers. A couple of such enquirers in the author's memory have thought of erecting a monument, but no firm proposal has ever emerged. Sadly, none of the monuments that once existed in St Mary's churchyard have been left in situ, much detracting from its appearance and historical value.

William Allen

William Allen was a nineteen-year-old resident of the Borough who was shot near the King's Bench Prison on 10 May 1768, during the troubles which attended the imprisonment there of John Wilkes. He was hit by accident in King's Place, on the eastern side of what is now the southern end of Borough High Street, opposite the junction with Borough Road. He had nothing to do with the demonstrations in favour of Wilkes or with their suppression. His death was a terrible tragedy, and his monument in St Mary's churchyard reflected his parents' grief and anger. The inscription on his table-tomb read:

> Sacred / to the memory of / WILLIAM ALLEN /An Englishman of unspotted Life and amiable /Disposition who was inhumanly murdered near St. George's / Fields on the 10th Day of May 1768 by Scottish / Detachments from the ARMY / His disconsolate parents Inhabitants of this /Parish caused this Tomb to be erected to an only Son / Lost to them and to the World in his Twentieth Year / as a Monument of his Virtues and their Affection.

Monumental Inscriptions

Robert Hovenden did a substantial service to future family historians when he listed all the inscriptions on the monuments in St Mary's churchyard. He also made extensive notes on the families and individuals, and published *Part I*, of the surnames from A to I, in 1880. All the original notes are preserved in the local history library in Southwark. An index of the entire collection, including the unpublished part from J to Z, was compiled by Wyn Poate, checked by Jean Dungate and published by the Society of Genealogists in 1995.

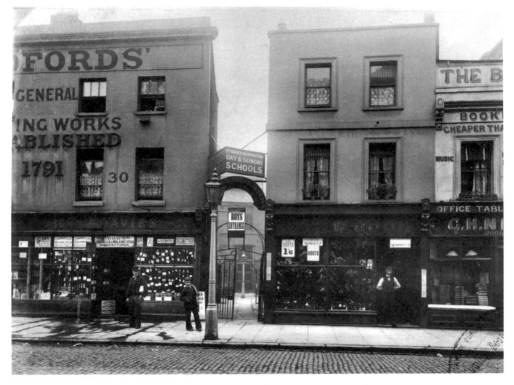

The entrance to the St Mary Newington Schools between Nos 28 and 30, Newington Butts.

St Mary Newington Schools

It is sad that the first school to be founded in the parish of St Mary, Newington, should have ceased to exist after the Second World War. Despite being affiliated to the principal church of the entire district, it was consigned to history. It began as the parochial charity school in 1710/11. The schoolroom and the master's house were built on a piece of copyhold land at the corner of Cross Street (later Draper Street) and Walworth Road. The land was thereafter known as the Charity School Copyhold Estate. Initially, it was only a boys' school, but later a girls' school was added. In 1816, these schools were merged with the parish's Sunday school. Four years later, they were moved to a site on the glebe land, north of the church, where the new leisure centre is presently being built. Rebuilding of most of the site took place in 1932; the Bishop of Southwark formally reopened on 20 January 1933 what were then called the St Mary, Newington, Church of England Day Schools. Great damage was inflicted on these buildings by bombing in the Second World War, and afterwards the schools were transformed into a Church of England secondary school, sited in Sancroft Street, Kennington. This lasted only until 1962, for a number of local Anglican secondary schools were merged in that period.

3

The Fishmongers' and Drapers' Almshouses

The Fishmongers' Almshouses

The most picturesque group of buildings at the Elephant were the Fishmongers' Almshouses, which stood in Newington Butts, immediately opposite the Elephant and Castle pub, until 1851. They belonged to the Fishmongers' Company of the City of London, one of the twelve great livery companies, whose stately hall stands on the upstream side of London Bridge and therefore faces Southwark. It is also a livery company which has kept a close connection to its trade.

The almshouses derived largely from a series of gifts in the seventeenth and eighteenth centuries. The will of Sir Thomas Hunt, dated 28 April 1615, promised £20 a year from his properties in Kent Street, Southwark, to pay for houses for six men or their widows. His son, William, then went further than his father's intentions in 1618 by making two deeds which provided £20 a year each. Meanwhile, the Fishmongers' Company had already decided to begin the almshouses out of money derived from the benefaction of Sir Thomas Kneseworth, given as far back as 1513. An agreement to build was made on 26 May 1617, and letters patent were obtained from King James on 2 October 1618. This royal document incorporated the Company's Court of Assistants as the Governors of the almshouses, with power to hold lands and to make statutes.

It was decided on 23 November 1618 that thirteen poor men and women were to be housed in the hospital by Christmas that year. Two more houses were ready by 1626, and a further seven by 1636. So when the first building (known as the Old Building) was completed in that year, there were twenty two dwellings with a chapel and a hall. It was formally known as St Peter's Hospital, since St Peter had been a fisherman. 'Hospital' was often used as a title for almshouses, for it derived from related Latin words whose basic meaning is 'host' and 'guest' (hence hospitality), and which then have the extended meaning of a place of refuge. In past centuries, this was applied to schools and almshouses as well as to places which treated the sick.

Kneseworth's money provided the endowment for thirteen places, six more were endowed by the Hunt benefactions and a further two from the gift of Richard Edmonds

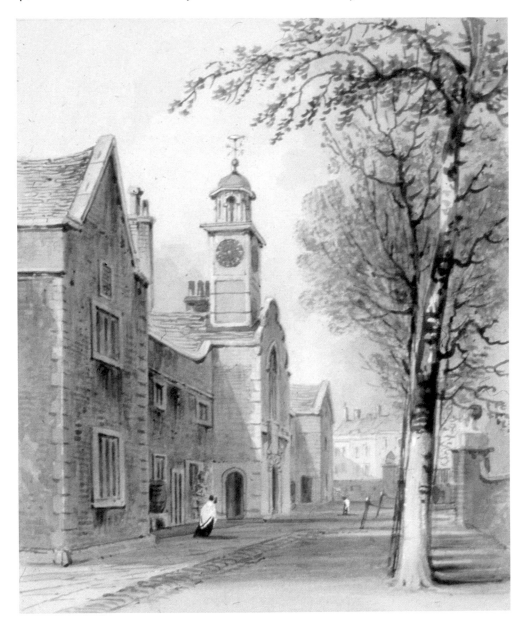

A view of the Fishmongers' Almshouses, 1851, showing the clock turret over the main entrance.

in 1620. This left one place from the twenty-two in the Old Hospital which lacked a specific endowment. This was eventually provided by the benefaction of William Hippisley in 1766. The residents all wore badges to indicate the endowments of their places. In addition to their homes, the residents received pensions, coals and cloth for gowns. All the residents were appointed by the Court of Assistants of the Fishmongers' Company.

A long brick wall enclosed the grounds of the almshouses along Newington Butts and was pierced by the grand entrance gates at its northern end. This led across a courtyard to the main doorway in the centre of the two-storey east elevation. Above the doorway was a Gothic window with intersecting tracery, representing the chapel, and then a shaped gable (typical of the middle of the seventeenth century), with a clock turret rising from the roof behind. At the top of the weather vane was a large fish. In the middle of the west side of the quadrangle was the dining hall, to correspond with the chapel on the east side. An extensive garden lay beyond. The hall had an ornate fireplace, with a large representation of the company's arms above.

The sum of £9,467 was given in the will of James Hulbert in 1719, which resulted in accommodation for a further twenty men and women, arranged round a new quadrangle – partly open to the east and west – on the south side of the original one. A statue of the founder was placed on a pedestal in the centre. Hulbert's foundation brought the total number of dwellings to forty-two.

A chaplain was employed at a salary of £52 10s 0d and a 'medical person', described as 'lately appointed' in 1824, was paid £25. These salaries were parts of an average annual expenditure over the previous ten years of £1,572.

Most of the illustrations of the hospital date between the mid-1820s and 1851, when it was demolished. John Chessell Buckler produced his usual pen and wash drawings in 1827/28, including one of the interior of the chapel, and there were a number of engravings and watercolours just before the hospital was closed. New almshouses were built at Wandsworth. It is a very great pity that the old hospital was not preserved; it would have been greatly treasured by later generations. The *South London Press*, in writing of the area in 1871, spoke of the former almshouses as 'the last remnant of rusticity near London in the south'.

Sir Thomas Kneseworth's benefaction was used in 1800 to purchase sizeable parcels of land on both sides of the Walworth Road, just south of the Elephant and Castle, including the sites of the future Newington Vestry Hall on the corner of Wansey Street and the future Newington Library immediately south of it. All this land became the property of the Fishmongers' Company in general and had no direct connection with the almshouses. Small plaques were attached to buildings on the estate to indicate the company's ownership.

At No. 5 St George's Road, a pub called the Fishmongers' Arms stood on the east corner of Pastor Street (originally Temple Street) for some generations.

The Drapers' Almshouses

John Walter, who was the Clerk to the Drapers' Company from 1616 until his death in 1656, founded two sets of almshouses in his lifetime, stating that he was moved to do so because 'many had lately perished by lying abroad in the cold for want of habitation to the great dishonour of God'. His will bequeathed money to endow his foundations, and then his daughter, Ann Mills, and her sons, provided further endowments.

The almshouses were provided for the two adjoining parishes of St George the Martyr, Southwark, and St Mary, Newington, the boundary between which cuts through the Elephant and Castle. The St George's almshouses were built away from the Elephant and do not concern us here. The Newington almshouses, however, stood for 300 years at the junction. They were built in three phases: the original set; and then additions of 1778 and 1820. As John Walter had given them to the parish, the Newington Vestry chose the residents. This was done by election, and it does not take much perusing of the vestry minutes to see that in Georgian and Victorian times, the elections constituted a sizeable part of the vestry's business. Special prayers were said at each election.

The almshouses stood in Cross Street, which was renamed Draper Street in 1868. Draper House at the south end of the present centre of the Elephant and Castle continues the association, though it is a block of flats owned by Southwark Council and has no link with the Drapers' Company. It stands on what was once the south side of Draper Street. The almshouses in Draper Street managed to survive the Second World War, when numerous properties very close to them were destroyed. They were

St Mary Newington Almshouses of 1894/95, on the corner of Clock Palace and Hampton Street.

compulsorily bought by the London County Council and demolished in 1956 to make way for the Elephant and Castle redevelopment. The London County Council rehoused the displaced residents temporarily until new permanent almshouses could be erected.

Walter's Trust and the Drapers' Company collaborated in building the new almshouses, which were named Walter's Close. This development, remarkable for its time, was built in a block of land bounded by Brandon Street, Larcom Street, Content Street and Wadding Street, a few hundred yards east of the Walworth Road. The architect was Ernest Berry Webber and he provided a building in traditional style, which was strikingly handsome and sympathetic in contrast to the ugly structures going up at that time at the Elephant and Castle. It cost £40,000 and was formally opened on 18 October 1961, by the Master of the Drapers' Company and was dedicated by the Bishop of Southwark, Mervyn Stockwood. To begin with, the two-storey buildings formed three sides of a garden court, with a clock turret in the centre of the longest side. The pitched roofs were given Westmoreland green slates. The arms of the Drapers' Company and the shield of Walter's Trust were placed on the buildings. Nominations of the majority of residents in the new set of buildings were to be made by the trustees of the United Charities of St George the Martyr, Southwark, and of the United Charities of St Mary Newington. A complete quadrangle, equally agreeable, was added later on an adjoining site immediately to the north.

St Mary Newington Almshouses

The increasing surplus income at the disposal of the Copyhold Charity Estates led to the foundation of these almshouses. The decision was made in 1892 but building did not take place until 1894/95. George Lansdown seems to have been the architect. The site chosen was on the east corner of the junction between Clock Place and Hampton Street, a quiet corner beyond the south end of the Elephant. These buildings were eventually replaced by St Mary Newington Close in Surrey Square, which was opened on 27 October 1969.

<p style="text-align:center">4</p>

Early Modern Newington

The Elizabethan Theatre at Newington

Until the mid-eighteenth century, Newington's history was that of an unexceptional village on the Portsmouth road. It had little more than its parish church and some picturesque almshouses to be noticed. In its earlier history, however, it did boast one short-lived institution, which is of considerable interest. This was an Elizabethan theatre, which was certainly close in date to the acknowledged pioneers in the field, 'The Theatre' and 'The Curtain', and may even have predated them.

The Newington theatre's history has been discussed by a number of writers, but there is no doubt that the paper by William Ingram in the *Shakespeare Quarterly* in 1970 is the most masterly, founded on good documentary sources. The basis of his investigation of the theatre's existence and site is the archive of the Dean and Chapter of Canterbury's manor of Walworth.

A group of six fields in the manor on the eastern side of the Walworth Road was normally leased as a single landholding, which totalled about 35 acres. Its western side consisted of a field which fronted the Walworth Road opposite the northern end of the larger of the two islands. This western field was called Lurklane, amounting to more than 10 acres, and it was in the south-western corner of this field, according to William Ingram's argument, where the theatre stood. A plot of around 1 acre in that corner eventually became a separate property from the rest of the field. This subdivision of Lurklane contained only two buildings: the theatre and a house. The southern edge of the original Lurklane and of the subdivision ran along the north side of a common sewer – a drainage ditch – which brought the site into the proceedings of the Surrey and Kent Commissioners of Sewers.

The 35 acres were leased from the Dean and Chapter of Canterbury in 1566 by Richard Hickes, who did not live at Newington. He had a close associate in Peter Hunningborne, and together they soon wanted to evict their tenant, James Savage, who was an actor in the Earl of Warwick's company. In 1577, they claimed him to be 'a verrie lewed fealowe and liveth by noe other trade than playing of staige plaies and

Interlevdes'. Savage appears to have built the theatre in 1576 or possibly in 1575, and it can be shown that he was the resident of the house in the subdivision from Lurklane. Savage ran the playhouse until 1580, despite his landlords' early hostility and the peremptory demands of government. The Privy Council wrote to the Surrey Justices on 13 May 1580, to report that despite an order to suspend the operation of theatres, 'nevetheles certen playes do playe sunderie daies every week at Newington Buttes'.

In 1580, the Earl of Warwick's players seem to have been replaced by the company under the Earl of Oxford. The players under Lord Strange [Ferdinando Stanley, Lord Strange, afterwards the Earl of Derby] may have appeared at Newington in 1592, and two years later Philip Henslowe arranged for the combined Admiral's and Chamberlain's players to act there for ten days, but with poor returns. Henslowe was a most significant figure in the theatres of the time, but his involvement at Newington was very brief and he was never the proprietor.

The playhouse seems to have become uneconomic and was demolished between 1595 and 1597, when Paul Buck was the owner of the site. So the theatre lasted for just twenty years or a little more, and had no great success or associations, probably because of its location, too far from London town. Nevertheless, it played a part – and an early part at that – in the great age of London's Elizabethan and Jacobean theatres. No illustration has ever come to light.

The Bridge and Watercourse at Newington

Just to the south of the Fishmongers' Almshouses there was once a bridge which carried the High Street or Newington Butts over a watercourse. An inscription was placed on the wall of the almshouses to record repairs to the bridge in 1691, 'at the charge of the inhabitants of Newington and St George's Parishes'. The minutes of Walworth's manorial court in the eighteenth century refer from time to time to the corresponding bridge carrying Walworth Road over the watercourse. For example, on 29 December 1748, the manorial court acted against the Surveyors of the Highways for Newington 'for not placing posts and a rail at the bridge near the Black Prince'. The Walworth Road side of the two islands was entirely within the jurisdiction of Walworth Manor. Finally, the minutes of the Surrey and Kent Commissioners of Sewers often mention the watercourse, which was an important object of their attention. It was popularly known in Georgian times by the grand name of the River Tigris.

This watercourse was in fact a 'common sewer', which meant a drainage ditch rather than a sewer in modern terms. It was part of a reasonably well-organised drainage system of the low-lying lands south of the Thames. The common sewer ran from Lambeth Marsh to Newington and then passed under the bridges in Newington Butts and Walworth Road. It proceeded eastwards through the meadows between the Walworth Road and the Lock Hospital at the southern end of Kent Street (now Tabard Street). It passed under the Lock Bridge and was known in that vicinity as the Lock Stream. Beyond that place, the sewer joined the Duffield Sluice system.

The Beginning of the Modern New Kent Road

Today's New Kent Road was laid out under powers granted in an Act of Parliament in 1751 (24 Geo. II, cap. 58): 'An Act for making, widening, and keeping in Repair, several Roads in the several Parishes of Lambeth, Newington, Saint George's Southwark, and Bermondsey, in the County of Surrey; and Lewisham in the County of Kent.'

The preamble of the Act refers to the completion of Westminster Bridge the previous year and earlier powers that had been granted to widen and to 'render more convenient' the approach roads to it. It specifies in a list of proposed new works 'another new Road, from the said Alms-houses at Newington [the Fishmongers' Almshouses], cross certain Grounds into the Kentish Road, near the Lock Hospital, at the end of Kent Street, in the County of Surrey'. Kent Street is the present Tabard Street, which was a built-up street whose continuation was the rural Kent Road, today's Old Kent Road. There was no Bricklayers' Arms junction in 1751; the nearest landmark was the Lock Hospital, then in its last days. The great prize of the proposed new road was to connect Westminster Bridge to the Kent Road, then as now a major route.

The route of the new road was to be up to 80 feet wide, with the roadway itself 42 feet wide. It was quite a stately road for its time, not merely in its dimensions but in some of the properties built there. As is usual in such cases, the properties followed some years later. The names given to parts of the street give some clue to their date. At the Elephant end, Rockingham Row was the name attached to a terrace of houses in the vicinity of the modern railway bridge: this alluded to the Marquess Rockingham (1730-82), Prime Minister in 1765/66 and again in 1782. Much later, of course, the name was also used for the street off Newington Causeway and for the London County Council's housing estate built between the world wars. Another name in and around New Kent Road referred to Admiral George Rodney (1718–92), whose victory of the Battle of the Saintes in 1782 brought him great fame and honour.

5

The Metropolitan Tabernacle

Today, the Metropolitan Tabernacle and the Bakerloo Line's Underground station are the only significant buildings to survive from the old Elephant and Castle. The Metropolitan Tabernacle now has a tremendous presence in the wide road at the centre of the current Elephant. Ironically, the building was formerly very difficult to see from the street unless you stood in front if it, because it was set well back from the old street frontage behind railings. If you looked north along the pre-war Newington Butts, from the north-east corner of St Mary's churchyard, you could not see the frontage of the Tabernacle, although from the churchyard you could certainly see its roof rising above the lower buildings nearer to you.

The present Metropolitan Tabernacle was opened in 1959 on the site of its predecessor, which had been destroyed by wartime bombing in 1941. The pre-war building in turn was a replacement in 1900 for the first Tabernacle, which had been burnt down two years earlier. And that first, much larger, structure was Spurgeon's own Tabernacle, which had been erected in 1859–61.

Charles Haddon Spurgeon (1834–92) is one of the most significant figures in the history of the Elephant and Castle and of Southwark generally. He not only built the biggest church in Victorian Southwark and drew stupendous numbers of hearers to it for thirty years, but also founded a considerable group of associated institutions that have influenced countless lives for a century and a half. At first glance he might seem a forbidding figure, especially if you read early on that in the 'Down-Grade' controversy of 1887 he castigated many of his fellow-Baptists for their drifting away from old Baptist beliefs (the controversy is discussed below on page 48). It might give you the superficial impression of a fierce and hard-line individual. But the more one learns of his life and his sayings, the more one is surely going to warm to him, whatever one's religious background may be.

For one thing, he appointed a Congregationalist as the first head of his Pastors' College. He did the same when his orphanage was opened at Stockwell. This hardly suggests a narrow or rigid denominational outlook. It is true that Congregationalists and Baptists shared a Calvinist background, but it is still most

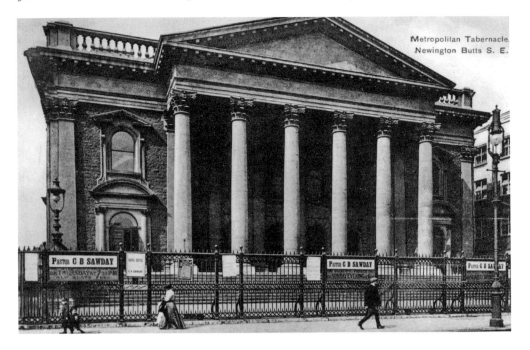

Metropolitan Tabernacle,
Newington Butts S. E.

unusual for one denomination to prefer the ministers of another, especially in positions of authority.

The children admitted to the orphanage came from all denominations, including even those of Catholic background. These decisions were all remarkably broad-minded for their time. Even more unusual was his attitude to alcohol. Whereas the Free Churches in general in the late Victorian period were strong proponents of teetotalism, he made clear that he was not a teetotaller, and added, 'and it is not likely that I ever shall be'. Instead, he advocated moderation (which is, in fact, what 'temperance' originally meant). And he made this agreeable declaration: 'Every member who joins my church is expected to do something for his fellow creatures.' Few people in the world would find that sentiment disagreeable. The honour given to him at his funeral on 11 February 1892, speaks volumes of the world's recognition of him as a worthy and benevolent individual; the mourners in the streets have been summed up as 'a crowd five miles long'. No fewer than 60,000 people passed before Spurgeon's coffin on 8 February 1892, and again on the next day. One tribute that 'he was big-hearted and good-natured', seems to sum Spurgeon up as well as any.

None of this is to suggest that he did not have strong beliefs, which he was always determined to preach. In his book, *The Metropolitan Tabernacle; its History and Work* (1876), he stated clearly: 'We are Calvinistic Baptists, and have no desire to sail under false colours, neither are we ashamed of our principles: if we were, we would renounce them to-morrow.'

Spurgeon arrived in Southwark as a Baptist preacher from Waterbeach in Cambridgeshire at the precocious age of nineteen. This was in December 1853. The message of St Paul to Timothy was invoked at this time: 'Let no man despise thy youth.'

He went to the New Park Street Baptist chapel, close to where the Globe Theatre and Tate Modern now stand. The chapel housed the congregation that had once worshipped in Carter Lane near London Bridge and much earlier (back in the seventeenth century) in Goat Yard, Horselydown. Its history had encompassed such eminent preachers as Benjamin Keach (pastor, 1668–1704), John Gill (1720–71) and John Rippon (1773–1836). It was a meeting at Carter Lane in 1812, under the presidency of Dr Rippon, which led to the foundation of the General Union of Baptist Ministers and Churches in 1813. This later became the Baptist Union of Great Britain and Ireland.

Despite this proud background, however, the New Park Street chapel was at low ebb by 1853. Spurgeon's arrival rapidly changed the situation. He was already 'the prince of preachers'. His preaching there on 17 December and on three Sundays in January led to his being invited early in 1854 to occupy the pulpit for six months. But well before the end of that engagement, he was asked on 19 April to become the pastor. His own verdict on that time was straightforward enough: 'The place was filling, the prayer-meetings were full of power, and conversion was going on.' Eric W. Hayden, author of the excellent book, *A Centennial History of Spurgeon's Tabernacle* (1962), commented in relation to his Waterbeach days: 'He may have been referred to as "the sauciest dog that ever barked in a pulpit", but many obviously wanted to hear the barking.' In Southwark, the same pattern was massively magnified. Very quickly, New Park Street chapel was seen to be too small. It could hold 1,200 people, but already Spurgeon had made it inadequate. It was enlarged, but Spurgeon said that this 'resembled the attempt to put the sea into a teapot'. Exeter Hall in the Strand and the Surrey Gardens in Walworth were therefore hired in turn. His preaching at Exeter Hall brought him to wider notice and prompted a few lampoons in the press, though none deterred him.

Right: Charles Haddon Spurgeon (1834–92), 'the prince of preachers'.

Opposite page: The exterior of the Metropolitan tabernacle, which formerly stood well back from Newington Butts behind railings.

At one meeting in the Surrey Gardens, on 19 October 1856, tragedy struck. While he addressed a congregation of 7,000 people, a false alarm of fire was raised, and in the ensuing panic, seven people were killed and twenty-eight were seriously injured. This tragedy shocked Spurgeon and for a while checked the progress of his work. Earlier in the same year, he had married Susannah Thompson, a member of his congregation.

In June 1856, a building committee was appointed to arrange a permanent replacement for New Park Street Chapel. The site at Newington Butts was bought from the Fishmongers' Company for £5,000. The new chapel was to cost £31,000. W. W. Pocock was its architect, and his design was Greek Classical, in marked contrast to most Anglican churches at the time. Spurgeon stated: 'The standard of our faith is Greek; and this place is to be Grecian. Greek is the sacred tongue, and Greek is the Baptist's tongue. Every Baptist place should be Grecian – never Gothic. This shall be a Grecian place of worship.' Greek was indeed the language of the New Testament, but the Christian Church grew up under the Roman Empire, and among Roman buildings. Even Athens, the principal Greek city, was substantially rebuilt by the second-century Roman Emperor, Hadrian. Classical Greek buildings from an earlier time were surely linked with pagan Greek beliefs – one thinks of the Parthenon in Athens itself, where Athena Parthenos was worshipped, and the great Temple of Diana at Ephesus. Nevertheless, Greek Classical buildings won Spurgeon's favour, and were also used by further Baptist congregations, which were quite separate from Spurgeon's. The Walworth Road Baptist Chapel of 1863/64 and the Surrey Tabernacle of 1864/65 in Wansey Street were both built in a similar style. They are discussed below. Spurgeon's builder was William Higgs, who was later to become one of his deacons.

Why Metropolitan and Tabernacle? Metropolitan is the adjective from the Greek word, *Metropolis*, meaning mother city, which was widely used in Victorian times because the name of London was considered to belong only to what we now call the City (hence Metropolitan Police, Metropolitan Fire Brigade, etc.). Tabernacle was a word used to refer to a temporary church, for example, to those built after the Great Fire of London of 1666.

The foundation stone was laid by Sir Samuel Morton Peto, Bt., MP, on 18 August 1859. Peto was a renowned contractor for public buildings, including Nelson's Column and the Houses of Parliament, and for railways. He was also a Liberal MP and a Baptist. The first meeting was held in the Tabernacle on 13 March 1861. It was 146 feet long, 62 feet high, 81 feet wide, and could accommodate 6,000 people. Six great columns supporting a pediment made a monumental statement to the world. This now shames the modern buildings around it. Originally, there were to be four large corner towers, two at the front and two at the back, but Spurgeon declined to spend £4,000 on what he considered to be unjustifiable adornments. It has to be remembered that when this great work was completed, reflecting an extraordinary expansion under Spurgeon's pastorate in Southwark, he was still only twenty-six.

The interior of the Tabernacle was galleried, with three tiers of seats. The focus was on the platform from which Spurgeon spoke. His achievement was rooted in his preaching. His addresses can be read in his magazine, *The Sword and the Trowel*, but you cannot appreciate his passion and fire from the printed word alone. Spurgeon must

have electrified his congregations to be so successful. He was undoubtedly an orator of the first order. Many people remarked on the clarity and power of his voice and on his ability to express different moods. He impressed many who were themselves regarded as great orators, including W. E. Gladstone, the Liberal Prime Minister, who heard him preach one Sunday evening in 1882, and David Lloyd George, a later Liberal Prime Minister. Spurgeon's sermons were printed not only in his magazine but were also published individually for the price of 1d each (half a present penny). No fewer than 108 million copies of his sermons were sold between 1855 and 1892. Even at 1d each, around £438,000 would have been produced, which would have been a huge fortune in Victorian times. Spurgeon paid for his own work by his income from writing, rather as Wesley did in the eighteenth century. He received no salary.

Singing was certainly encouraged at the Tabernacle, but Spurgeon disliked church organs. So the congregation was helped musically only by a precentor with a tuning fork. In an earlier phase of the congregation's history, at Goat Yard in Horselydown, a split took place over whether to have singing at all. In another case, a row over a church organ in Leeds actually led to the setting up of a new denomination, called the Protestant Methodists, whose members ran a chapel in Borough Road, near the Elephant and Castle, in the 1830s.

The statistics of Spurgeon's hearers and members were astonishing. The membership reached 4,813 in 1875. No fewer than 571 new members came in 1872 alone. The highest net increase in any one year before 1887 was 382 in 1864. Many members went on to Baptist churches elsewhere, especially new ones. By 1876, the Tabernacle's Sunday school boasted 1,000 children in regular attendance. To assist Spurgeon, twelve deacons and twenty elders were already in place by 1861. Early in 1868, his brother, James A. Spurgeon, became his co-pastor. Despite this designation, it was always accepted that he was assisting his brother and not running the Tabernacle. In fact, he ran a church of his own for many years at the same time: the West Croydon Baptist chapel. Unlike Charles, James had received formal training for the Baptist ministry at Stepney College (later called Regent's Park College) and he was rather less independent-minded than his brother.

The thirty years after the opening of the Metropolitan Tabernacle produced an equally astonishing growth of associated institutions. The Pastors' College was founded in 1856, following pleas for training from Tom Medhurst, a member of the Tabernacle, the year before. Spurgeon initially paid for the training himself, with help from two senior members of the congregation, but entrusted the actual tuition to George Rogers, an Independent minister from Albany Road, Camberwell. The work grew and constantly required more money. Eventually, this work became a proper college, and it was housed in new buildings behind the Tabernacle in 1874, costing £15,000. Despite Spurgeon's insistence on 'Grecian' architecture for the Tabernacle itself, these new buildings were Gothic. During the first 28 years of the Pastors' College, 675 men were trained for the Baptist ministry, representing a formidable influence of the Tabernacle in the wider Baptist church.

The Colportage Association, intended to circulate religious literature, was begun in 1866. By 1874, annual sales had almost reached £3,000, with thirty-five men

employed. The organisation was run on unsectarian lines, another instance of Spurgeon's broad sympathies.

A year later came the beginnings of the orphanage at Stockwell, prompted by a benefaction by a Mrs Hillyard. A site in Clapham Road was bought in 1867. It was decided to put the orphans into family groups 'instead of massing them together upon the workhouse system'. Individuals were asked to sponsor houses. The foundation stones of the first four were laid later in 1867. The initial buildings, comprising seven houses, a school room, dining hall, and the master's house, were all finished by the end of 1869, at the cost of £10,200. An infirmary, bathhouse and laundry were added later. There were 276 children in the orphanage by 1876.

New almshouses were built in Station Road, Walworth, in 1867/68, replacing a set founded by John Rippon in 1803. In addition to seveteen rooms for residents, there were two schoolrooms and the schoolmaster's house. Due to a lack of endowments, Spurgeon was paying the expenses himself in 1876.

Finally, there were the missions. Local ones were located in Richmond Street off East Street (1869) under J. T. Dunn, with new premises opened in 1875; Surrey Square off the Old Kent Road (1887); Surrey Gardens on the western side of Walworth (1890/91); Green Walk in Bermondsey; and Mr Hampton's Blind Mission, which eventually acquired a hall in Borough Road, a little north of the Elephant.

The great Down-Grade controversy of 1887/88 began with two unsigned articles in *The Sword and the Trowel* early in 1887. They were in fact written by Robert Shilder, a Baptist minister at Addlestone. They were noticed but caused few ripples. Later in the year, Spurgeon himself wrote three articles which enlarged upon the previous pair and implied that the Baptist denomination was harbouring preachers who had diverged from traditional Baptist tenets. This might simply have led to a gentlemanly debate, although Spurgeon's language was already rather too strident for quiet academic discussion of doctrines. Spurgeon basically thought that the wider Baptist Church was failing to uphold the Calvinistic doctrines that the denomination had traditionally professed. Spurgeon was entitled to draw attention to these doctrines, and of course to define them and to explain why he urged their retention. An argument had broken out a generation earlier in a similar manner. A sermon by Spurgeon on baptismal regeneration in June 1864 stated that only baptism by personal choice brought it, as well as a conversion from earlier beliefs or from a lack of them.

It would seem that he had long held the views which he put forward in 1887 about the alleged watering-down of doctrines, and was getting increasingly irritated that nothing was being done to arrest the slide. He privately expected a swift chorus of approval from the Baptist Union. When nothing happened at an official level, he suddenly resigned his membership at the end of 1887. Given his great prominence, and the fact that the Baptist Union had been founded in an earlier home of the Tabernacle's congregation, this was a huge step. His resignation took everyone by surprise, for he had not attended meetings of the Baptist Union for a few years and had not tabled any proposals for discussion. He had clearly detached himself from the centre of things even further than what one might call his busy independence. He was also ill from time to time and was gradually becoming more set in his ways. None of these matters helped in 1887/88.

The formal response by the Baptist Union Council on 18 January 1888 was unfortunate in that it included a rebuke. Although Spurgeon's articles had been rather strident, a more generous initial response might have cleared the way for a calm discussion of basic beliefs, as eventually happened, without the difficult moments of Spurgeon's resignation and the subsequent rebuke. Most members saw the Baptist Union in 1887 as an essential administrative body and as involving no intolerable theological divisions. The controversy had obviously been to the forefront of Spurgeon's mind for a long time without it being widely known, let alone being discussed. Years later, Spurgeon's son, Thomas, remarked, 'The Baptist Union almost killed my father'. Archibald Brown, who became the Tabernacle's pastor in 1908, replied, 'Yes, and your father almost killed the Baptist Union!'

Spurgeon preached for the last time at the Elephant on 7 June 1891. He died at Mentone in the south of France in 1892 and was buried in the South Metropolitan Cemetery at Norwood. His brother, James, for many years the co-pastor, briefly became Acting Pastor. This lasted until Charles's son, Thomas, was invited to be pastor in 1893. Thomas then remained in office until 1908. He had been born in New Kent Road and had grown up in the heyday of the Metropolitan Tabernacle. His ministry suffered the great fire of 20 April 1898, in which the Tabernacle was destroyed; and he then oversaw the erection of a new one on the same site for £45,000, albeit with 'only' 3,000 seats, considerably fewer than the original. Thomas's health gave way in 1907, but he was persuaded to rest rather than resign. A co-pastor was once again appointed: Archibald Geikie Brown. He had enrolled at Spurgeon's College in 1862 and had gone on to run the East London Tabernacle for some thirty years until 1896. In 1908, Thomas Spurgeon did resign (he lived until 1917), and Brown became pastor. He held office only until 1911. His ministry was perhaps a useful bridge between that of the three Spurgeons and the more detached succession in the twentieth century.

The Metropolitan Tabernacle's institutions were gradually dispersed after the First World War. The Pastors' College removed to Beulah Hill in 1923 and flourishes there today after a recent major redevelopment. The Stockwell orphanage was transferred to Reigate at the beginning of the Second World War in 1939, and was afterwards rebuilt at Birchington in Kent in 1953, under the new name of Spurgeon's Homes.

The bombing of the second Tabernacle in 1941 left a gap for nearly two decades. For a long time the proposals of the London County Council for the Elephant's redevelopment seemed to exclude the Tabernacle altogether, and in any case there was thought to be insufficient money to rebuild. Gradually, however, the projected compensation from the War Damage Commission got larger, and the London County Council then agreed that rebuilding could take place on the old site. R. Mountford Pigott was appointed as the architect, and in 1958/59 the third Tabernacle was erected, reusing the old façade. It was opened on 24 October 1959, with 1,750 seats – still a very large church. This was during the pastorate of Eric Hayden (from 1956), who wrote the well-balanced and eminently judicious centennial history book, published in 1962. In 1970 there began the ministry of Dr Peter Masters, which continues to this day. Over those decades, the Tabernacle has been very widely advertised, on Underground trains for example, and flourishes as an evangelical cause in Spurgeon's tradition.

6

Entertainment

The South London Music Hall, Later the South London Palace of Varieties

The South London Palace of Varieties was a very well-known place of entertainment at the Elephant. Before the Trocadero was opened in 1930, it was the most popular. It was founded in 1860 as the South London Music Hall and took its place as a leading establishment in the great days of the Victorian music hall. Charles Morton, 'The Father of the Halls', managed it in the later part of his career. He had been a pioneer of the type at the Canterbury Music Hall at the Lambeth end of Westminster Bridge Road, and had later been in charge of the Oxford and the Tivoli, important central London halls.

The South London Music Hall was opened at No. 92 London Road, on the eastern side of the street, on 30 December 1862. The site had been bought in 1860 by James Frederick Tindall and Edwin Robert Villiers. On that site had stood a long-closed Catholic chapel, the London Road Chapel. Burials that had taken place there were removed to the vault of St George's Cathedral, a little distance away. The music hall was always flanked by shops, for London Road was lined on both sides with shops (plus a few pubs) until the Second World War.

William Paine was the architect of the first building. Unfortunately, it lasted only six and a quarter years, for it was burnt out on 28 March 1869. Fires in theatres and music halls were quite common in the nineteenth century and resulted in many safety precautions being imposed by the Metropolitan Board of Works and later by the London County Council. 'The South', as it was widely known, was quickly rebuilt, for it reopened on 19 December 1869, only nine months after the fire. It then remained in use well into the late 1930s, in the heyday of cinemas. In 1941 the building was badly damaged by bombing. The auditorium was demolished in 1955, but the façade to London Road remained until 1961.

It was the essence of music halls in their heyday that popular 'turns' would sing their best-known (or, at least, their latest) song in a great number of halls, often in a

succession in the same evening. The most eminent performers were known as 'Lions Comiques'. These included George Leybourne, the original Champagne Charlie. Although he came from the North East of England, he had many local links. He got married in Bermondsey Parish church (St Mary Magdalen's) in 1865, and had a daughter, Florence. She eventually married Albert Chevalier, who made famous the song 'Knock'd 'em in the Old Kent Road'. It is an interesting twist to the story that Leybourne came from a poor background, but played the part of a West End 'swell', whereas his son-in-law, who had enjoyed a comfortable background, took up the role of a costermonger. They were obviously very good actors.

Leybourne's great song was his eventual downfall. It was an advertising song for Moët & Chandon's champagne, and he was given a supply of it, as well as rather a grand carriage between music halls. As a result, he lived to be only forty-two. His grave in Abney Park Cemetery at Stoke Newington is also that of his daughter and of Albert Chevalier.

John M. East, who was later to run the Elephant and Castle Theatre, was appointed production manager at the South London Palace in 1893 and manager in 1895. His grandson, also John East, published a book about him in 1967 entitled *'Neath the Mask*.

The Elephant and Castle Theatre

The Elephant and Castle Theatre had a relatively short life for stage shows, but nevertheless made a great name for itself from its fare of melodrama and pantomime. It also has the distinction that alone of all the places of entertainment in the Elephant's heyday, it gave rise to later establishments on the same site and within the same shell, the latest of which survives today.

The original theatre was opened on 26 December 1872. E. T. Smith, who promoted the development, was a notable entrepreneur in popular entertainment. It was he who transformed an old 'panopticon' in Leicester Square into the well-known Alhambra Music Hall. The Elephant and Castle Theatre was designed by Messrs. Dean, Son & Mattham of Mark Lane in the City, and built by Giles Bennett. There were 1,500 seats in the pit, 250 in the stalls, 800 in the gallery and 500 in the boxes.

This building lasted for just a few years, for it was burnt down on 26 March 1878. The adjoining platform of the London, Chatham and Dover Railway's Elephant and Castle station was damaged in the blaze. The observant reader will note that the Elephant's main Victorian places of entertainment were all burnt down at some stage. Rebuilding was soon undertaken in this case, and the second theatre was opened on 31 May 1879. The first programme was 'Raised from the Ashes'. The building was now much larger and offered more accommodation. The auditorium lay behind the adjoining shops in New Kent Road, and ran as far as the railway viaduct. It had a domed roof, from which was suspended a 'sun-light' or chandelier, consisting of no fewer than 206 jets, made by Messrs Berry & Son. There were exits from the stalls and the pit into Caroline Place, which ran westwards into Walworth Road.

According to *The Builder* (7 June 1879), 'The late Mr. Robinson, architect to the Lord Chamberlain, designed the building, which has been carried out under the

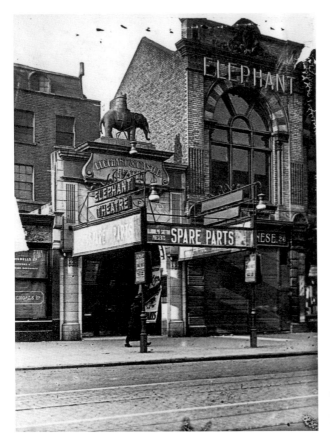

The Elephant and Castle Theatre in Edwardian days, when John East was the manager.

personal supervision of Mr. Frank Matcham'. So it did receive the attentions of that great architect of theatres, even if he was not the 'only begetter'. But Matcham was certainly the sole designer of the decorations, which were carried out by Messrs Rashley, Newton & Young of Red Lion Square in Holborn. The contractors for the building of 1878/79 were initially Messrs Bracker & Co., and then J. H. Brass of Chelsea. There was a fire in 1898 which was widely noticed in the press. It was soon brought under control and caused no gap in the programme, but it could easily have become a repeat of the disaster of 1878.

Despite the theatre's success, at least in certain periods of its history, opinions of it often emphasised its rough-and-ready air. One of the contributors to the series of memories of the Elephant published in 1957 by the *South London Press*, bluntly stated: 'The Elephant and Castle gallery was reputed to be the dirtiest in London. The ceiling was low, and covered with chews of tobacco, which the clients used to throw up there'. After the theatre's closure in 1928, a writer in *Notes & Queries* remarked that 'it retained its atmosphere of shawled women, odorous oranges, and caged gas-jets until the last'. After the opening of the Elephant and Castle Repository, it was said that 'a prevailing odour of horses and leather emanated from the enormous livestock auction-rooms that adjoined the theatre'.

John M. East, writing about his grandfather in 1967 in *'Neath the Mask*, prepared the way for a frightful description by saying, 'There was little to gratify the delicate eye in the Southwark of 70 years ago'. He then went on to report that performers who failed to come up to expectations were given no quarter by the audience. In particular, if a performer failed to speak up or sing clearly, the cry would go up, 'Where's yer 'obsons?' ['obsons' being short for Hobson's choice, which is the Cockney rhyming slang for voice]. This might be the cue for missiles to be thrown from the gallery. John M. East explained: 'The youth of the Borough seldom wore collars, and were unencumbered by underclothing. Experience had taught them that a shirt open from the neck to the waist provided the perfect resting-place for a sausage or a piece of fried fish, and left the hands free to applaud the actors' – or, of course, to do the opposite and to throw things at them. The theatre made a profit as much by food and drink as by the plays.

Bizarrely, missiles could indicate success as much as failure. Mrs Alice Rogers wrote in 1957:

> I remember the old Elephant theatre when "Driven from Home" was being played and the villain was so realistic that the audience threw tomatoes, eggs, bottles, anything they could lay their hands on, at him. Deeply gratified, he bowed, again and again. He knew that he had made good with one of the most critical audiences in London.

John M. East's grandfather had a major hand in the theatre from 1900 to 1907. In 1906 and 1907 he was the General Manager under the owner, Henry V. D'Esterre. In offering East the position, D'Esterre rather grandly referred to the 'Theatre Royal, Elephant and Castle' [don't laugh!]. John East was very thoroughly versed in theatrical life and had a fondness for grand spectacles. The *South London Mail* said of him that he was 'a gentleman responsible for many happy hours of make-belief at our local theatre'. There was a great deal of melodrama, as you would expect, and all the Victorian staples. *East Lynne* was repeatedly staged in John East's time. Although a tall and apparently forbidding man, he had a sense of humour. A comedian in a pantomime who had said, 'I've got plenty of gags up my sleeve, Mr. East', but fell short of what was needed, was approached by East after the first night. He said nothing but shook the sleeve of the comedian's coat. By the middle of 1907, receipts were falling, largely due to the pull of the new 'picture-palaces'. D'Esterre decided to sell, and from 1908 until its closure twenty years later, the theatre was owned and managed by Charles and Sidney Barnard.

Melodramas were not peculiar to the Elephant and Castle Theatre or to South London in general, but there has always been a tendency to think of them as being typical theatrical fare south of the river. *Sweeney Todd*, *Maria Marten* and *Jack Sheppard* were the leading old staples.

Of these, *Maria Marten* was based on a murder that had occurred in 1827. She met her end in the Red Barn at Polstead in Suffolk at the hands of her lover, William Corder. He was tracked down to a boarding house in London and was put on trial for murder. He was found guilty and was hanged at Bury St Edmunds before a huge

crowd on 14 August 1828. *Jack Sheppard* was the story of a robber and burglar who lived from 1702 until his execution at Tyburn on 16 November 1724; he was well known for escaping from custody on four occasions in increasingly unlikely circumstances. He was the subject of many plays and poems in the eighteenth and nineteenth centuries, but for forty years during the nineteenth century, when the Lord Chamberlain had to license plays, the subject was forbidden, to avoid giving celebrity to a felon.

Sweeney Todd is often thought of as a very old tale, but its classic stage version derives from a 'penny dreadful' called *The String of Pearls*, dating from 1846/47. What it did draw upon from earlier times were stories of dubious pie fillings. Todd is a barber at No. 186 Fleet Street (hence the usual subtitle, *The Demon Barber of Fleet Street*), next to St Dunstan's church, who kills and robs his customers. His accomplice and lover, Mrs Lovett, has the victims made into pies for sale in her adjoining shop in Bell Yard. 'Sweeney Todd' became Cockney rhyming slang for the Flying Squad in the twentieth century.

A further popular play was *East Lynne*, based on a sensational and bestselling novel of 1861 by Mrs Henry Wood (Ellen Wood). The main character, Isabel, is the aristocratic and restless wife of a stable but dour man. She leaves him and their children for a raffish lover, who then leaves her in turn. After suffering injury in a railway crash, she returns to her old house as a servant, unrecognised due to her injuries and to her own efforts at disguise. Her original husband, Archibald, has remarried. The plot is full of twists and tensions.

The Colleen Bawn [meaning 'fair girl' in Irish Gaelic], was based on a melodramatic play of 1860 by Dion Boucicault and before that on a novel by Gerald Griffin entitled *The Collegians*. But behind both was the real life murder of Ellen Scanlan in the west of Ireland in 1819. The plot in the later play is a complicated one, in which the young woman of the title is at one stage the intended victim but is not actually murdered. Until a few years ago, there was a public house of the name at No. 196 Southwark Park Road, in 'the Blue'; it is now a solicitor's office.

The old melodramas were being performed with great success by the Elephant Repertory Company in the last years of the theatre. The company was then led by Norman Carter (or 'Tod') Slaughter. He went on to make films of some of these melodramas, usually acting the villain's role. He starred, for example, in films of *Maria Marten* in 1935 and of *Sweeney Todd* in 1936.

Jack Sheppard was performed for the last time on 1 June 1928, after which the company and audience joined in singing 'Auld Lang Syne' and then 'Knock'd 'em in the Old Kent Road'. It seems odd that a successful and popular phase in the theatre's history should have been followed by closure. The theatre was sold to a new company in which C. B. Cochrane had a leading interest. The plan was to build a new and larger theatre, but it failed to materialise. C. B. Cochrane and his company were upstaged by the rapid appearance of the Trocadero opposite. The theatre was sold instead to ABC Cinemas and was converted to cinema use. It was reopened on 22 December 1932. The sum of £80,000 had been spent on recasting the old auditorium. A Christie organ had been installed in the orchestra pit. Provisions of facilities for stage shows had been made, with dressing rooms and elaborate stage machinery. The *South London*

Press of 23 December remarked that 'Gone are the sombre colour-washed walls, the musty smell, and the old-fashioned lighting, which gave atmosphere to the melodrama that thrilled the patrons of the old "Elephant"'.

The building was still called the Elephant and Castle Theatre after 1932, even in the 1960s, but from 1967 it was formally called the ABC. In 1987 it was renamed the Coronet. Six years earlier, in 1981, it had been closed between 26 January and 7 May to make it into a three-screen cinema. Finally, in 1999 it was changed into a live music venue.

The King's Hall

A royal wedding lay behind a party that took place in the King's Hall ninety years ago. On 26 April 1923, King George V's second son, the Duke of York, married Lady Elizabeth Bowes-Lyon. They were to become King George VI and Queen Elizabeth in 1938, and the bride of 1923 was to become familiar decades later as the Queen Mother.

The Duke of York gave the sum of £2,500 – a vastly larger sum then than it seems to us today – so that 8,200 schoolchildren could share the celebration of his wedding. The children were selected from the London County Council's schools. Parties were held in each of the Metropolitan Boroughs. Tea and musical entertainment were provided. Also, each child was given a box of chocolates, a share of the 4-foot-high cake made for each party, and a small piece of the actual wedding cake.

Southwark's party took place in the King's Hall, a building that is dimly remembered now. It stood on part of the site of the present London South Bank University. It was located on the north-east corner of a street called St George's Market, running from London Road to what is now Keyworth Street (previously Dantzic Street). The east end of St George's Market had been named Butcher Row, because of the meat that was once handled there. The name of Keyworth Street was chosen to honour Leonard James Keyworth, who won the Victoria Cross for an action at Givenchy in 1915, when he was serving in the 24th Battalion of the London Regiment, Walworth's Territorial regiment.

William Hurndall opened the King's Hall on 31 August 1909, primarily as a venue for dancing. He was a dancing master, but was his own architect and builder for his new hall. The building served purposes in addition to dancing. It was used for boxing, for the showing of films and, as we have seen above, for occasional special events. In 1957, when the *South London Press* published a long series of memories of the Elephant and Castle, boxing was misleadingly given prominence. One correspondent, Mr S. Mancini, Senior, a member of a well-known boxing family, wrote that 'there were some good fights there until the Ring opened'. The Ring was the old chapel in Blackfriars Road, for long known as the Surrey Chapel, which Dick and Bella Burge adapted for boxing between the two world wars. One of the boxers who fought there was Alf Mancini, a relation of the correspondent in 1957. Another, very celebrated, boxer to fight there was Bombardier Billy Wells (1889–1967), a very successful

heavyweight. He won four fights there in 1910–12. It is interesting to note that in 1913 he fought (and won) against Ex-Gunner James Moir at the Canterbury Music Hall a little way down the road into Lambeth; 'Gunner Moir' was later to be on the staff of the Trocadero at the Elephant.

In truth, boxing played only a small and temporary role at the King's Hall, and is now no more than a footnote of history. Another writer at the time referred to the King's Hall more appropriately as 'a 6d. dance palace', and added, 'it was the first place to hold select public dances, and how sweet was the music for a mere quartet of musicians glad to earn a bob or two'. In later days, after the Second World War, the hall was known as the Shamrock Dance Centre, serving an Irish clientele. The building was demolished along with much nearby property when the former Borough Road Polytechnic expanded from its original home in Borough Road and became the London South Bank University.

The building was an irregular shape, rather like a wedge of cheese. It had a small tower at the south-west corner, but its frontage to St George's Market was remarkably plain, with windows only at the upper level. At ground-floor level, there were several doorways. The frontage to Keyworth Street revealed what we might call a gable end (although the gable was flattened) and also a lower extension to the north. According to the *South London Press* in 1923, the building was widely known as 'the hall of a thousand lights', and in that cheerful interior, many poor children were the guests of a future king.

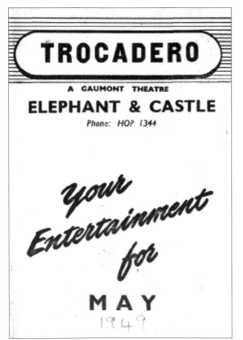

Programmes of 1949 and 1954 from the Trocadero. Note the words 'A Gaumont Theatre'.

The Trocadero Cinema

The Trocadero Cinema was one of the most distinguished buildings in the Elephant and Castle's history, and it was a considerable tragedy that it was demolished after such a short life (1930–63). The cinema was built on the site of Sandow's, which had previously been part of Tarn's department store, on the north side of New Kent Road, immediately east of the Rockingham Arms.

The Hyams brothers, Sidney, Philip and Mick, sons of a London baker, collaborated with Major Arthur John Gale (1881–1947) in the building of the Trocadero. A firm called H. & G. Kinemas Ltd had been formed in 1929, by which time the collaborators had all enjoyed long careers in the world of cinemas. Major Gale had been a cinema pioneer before the First World War. The age of super-cinemas had begun, and the Elephant and Castle was to have one of its most spectacular examples.

It was to be one of three cinemas with similar names; its siblings were the Trocette in Tower Bridge Road (built in 1929, but originally called the Super) and the Troxy in Stepney (1933). The Trocadero itself was originally due to be called the Broadway. Its permanent name derived in the first instance from the Trocadero Restaurant near Piccadilly Circus, which was popular with folk from the world of film. This was named in turn after the Palais du Trocadero in Paris, and ultimately after a battle in Spain in 1823, when a French army defeated Spanish liberals who were trying to overthrow the King of Spain. Ownership eventually passed to the Gaumont-British Theatres, in which the Hyams Brothers and Major Gale retained shares.

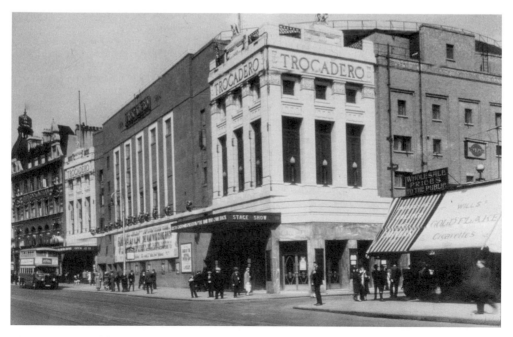

The Trocadero in New Kent Road, 1935. The Rockingham Arms is the taller building to the left.

It is often said that the Trocadero was intended to offer to South London 'a theatre equal in every respect to the best in the West End of London, at prices which are within the reach of the humblest purse'. Note the word 'theatre', as opposed to cinema: this usage persisted, for in later days the building was advertised as 'A Gaumont Theatre', and visitors were always being urged to use 'the theatre restaurant serving fine food in comfort'. Comfort was everywhere at the Trocadero. It is a commonplace to say that films take the viewer into another world, but it also needs to be emphasised that an establishment such as this offered luxurious accommodation well beyond what its patrons could enjoy at home. The premises themselves were therefore a major attraction. There were fully carpeted waiting rooms, heating everywhere, a restaurant, and the huge auditorium, elaborately decorated and arranged so that the screen and the stage could be clearly seen from all seats. The words of Dickens's great character come to mind: 'This', said Mr Pickwick, looking round him, 'this is, indeed, comfort'. It inevitably became a meeting place and a centre of local social life.

George Coles designed the Trocadero. The frontage to New Kent Road consisted of two flanking parts in white stone with what amounted to tall square columns bearing capitals, which looked Classical from a distance but were of their own special kind. The western or left-hand portion, next to the Rockingham Arms, was placed at a slight angle to the rest of the façade. The two flanking portions each had the word, Trocadero, labelled in large capital letters towards the top, with a central stone panel above bearing an eagle and a tall flagpole. This treatment also applied to the sidewall of the eastern corner, facing Tarn Street.

The main part of the façade was in brick, but with five white-framed vertical recesses housing up to three tiers of windows. Large floodlights were trained on this part from below, although there was actually less to illuminate than in the flanking portions. The plain brick façade above the windows bore the name of the cinema in the centre. In later years, the name was displayed on this part in a huge semi-circular arrangement in red letters superimposed across the tiers of windows. The interior was lavish. The white-fronted ends of the façade had doors which led into foyers and waiting rooms. The auditorium was built at an angle to the façade, with the screen and stage towards the rear right-hand corner. It featured ornate arcading, mouldings and lighting, comparable with those in a palace or stately home.

The Wurlitzer (or, to be precise, WurliTzer) organ was a very famous feature of the Trocadero, and miraculously it survives today. Given its huge size and innumerable parts, the miracle lies in its surviving the endlessly complex task of dismantling it safely and re-erecting it, not once, but twice. It was removed in its entirety from its original home and was eventually re-erected in the Edric Hall of what was then the Polytechnic of the South Bank (now the London South Bank University). Sunday afternoon recitals were offered there for a number of years. Then the organ was removed again and put into safe storage until its recent 'homecoming' of a sort, not to the Elephant but to the surviving Troxy building in Stepney. It is extraordinary that such a complex instrument should have got through all these moves, and have ended up in another Hyams Brothers' building. Its original cost was £15,000.

The word 'organ' prompts most people to think of churches, but this Wurlitzer was intended to present orchestral music. It is technically described as a 4/21, a very large and special instrument indeed, and was blessed by being placed in a building with excellent acoustics. In its early years it was played by Quentin Maclean, who became a celebrity in his own right. He left for Canada after his farewell performance on 23 May 1939.

The Trocadero was opened on Monday 22 December 1930, on a very foggy day. Thousands turned up, requiring a large police presence. The crowd wanting to buy tickets caused a further crowd to develop, to see what was going on, and the band of the Scots Guards playing within the building attracted yet more people. Even after 6.30 p.m., when it was announced that all seats were sold except for some at 1s 6d (7½p), about a thousand people queued for them. The fog put New Kent Road into further turmoil, for the trams were all but halted, and only the Tube was available when the cinema eventually emptied. In the previous few days, equally large crowds had seen the building in a series of previews. Some 25,000 people had seen the building over the weekend. On the previous Thursday, the Mayor of Southwark and further South London representatives had made formal visits. The new building offered 3,379 seats. The cheapest seats were just 6d (2½p). There was a permanent staff of 300, who included 'Gunner' Moir, a well-known ex-boxer. The *Daily Telegraph* reported that Moir was there 'not to "Knock 'em in the Old Kent Road", but to train the staff in physical fitness'.

The showing of films may have been the main purpose of the Trocadero, but a great deal more was offered there. Above all, there were stage shows between films, and on occasions the performers in these shows were as famous as any actor in the films. For example, on 21 November 1938, Paul Robeson came to sing for six days, at 3 p.m., 6.30 p.m. and 9.50 p.m. each day. Lawrence Brown accompanied him on the piano. Robeson had made a great name for himself in *Show Boat* at Drury Lane, and as an actor in the West End. The *South London Press* commented on 18 November: 'Robeson comes to the Troc. on Monday an epic figure. The Troc. audience likes a big man. Robeson is that in every sense of the word.'

On various occasions, live circuses were held at the Elephant. One of them took place in 1939, in the early months of the Second World War. At that time, prior to his being called up to serve in the RAF, Denis Norden was the assistant manager at the age of just eighteen. He was asked to unveil a commemorative plaque in New Kent Road on 4 June 2008, which had been arranged by the Cinema Theatre Association, and he gave a most entertaining speech. The circus included elephants, appropriately, who were found a billet, but the three lions were much more of a problem. Jocular suggestions of using the Lyons Corner House did not help, and in the end they were kept in a large cage at the back of the stage. But that week, there was an MGM film, and so when Leo the MGM lion roared, he was answered by the real ones in residence. At Denis Norden's unveiling of the plaque, a very nice touch was the provision of refreshments by Messrs. Gradzinski & Daughters, who are related to the Hyams family's bakery business.

A very surprising master of entertainment at the Trocadero after the Second World War was Sir Thomas Beecham. His Concert Society, with the help of the Arts Council

of Great Britain, collaborated with the J. Arthur Rank Organization in staging Sunday Symphony Concerts from late in 1948. Sir Thomas conducted the Royal Philharmonic Orchestra. He declared himself pleased that good music was spreading beyond central London, and pointed out that the Gaumont Cinemas had provided an excellent answer to the problem of finding venues of sufficient size. One of his Trocadero concerts, in 1949, consisted of Tchaikovsky's music: the *Swan Lake Ballet Suite*, the *Nutcracker Suite*, and his Symphony No. 6, the *Pathetique*.

The Trocadero was closed on 19 October 1963, which was as sad a day as the end of the grand Elephant and Castle pub in 1959. It was the result of the triumph of television over cinema in the post-war years, of a lack of thought about the building's potential uses, and the disdainful indifference of the London County Council's steamroller redevelopment scheme.

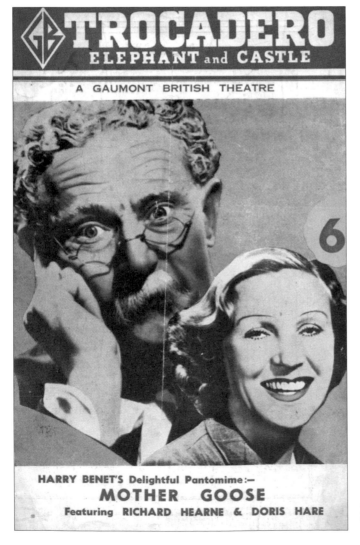

Programme from the Trocadero.

Trap Ball

There is a well-known picture in Warwick Wroth's *The London Pleasure Gardens of the Eighteenth Century* (1896) that shows the game of trap ball being played at the Black Prince, Newington Butts, in 1788. The location can be established precisely, because Cary's map of London in 1787 labels a green space as a trap ball ground. The game was an ancient one that was fading by the late eighteenth century. A wooden trap was used to throw a wooden ball into the air, so that a player could hit it with a short bat. In the picture, we can see a scorer's table, a ground marked by a line and flags, and opposing players beyond the line waiting to catch the ball. Newington Butts in the title of the print refers to the village rather than the street, for the Black Prince stood on the eastern side of the northern end of Walworth Road.

Derby Day

Before the First World War, Derby Day was a considerable occasion at the Elephant and Castle. This most famous of English horse races takes place at Epsom, whose principal approach from London took the traveller along Newington Causeway and Newington Butts towards Kennington and Clapham. There are countless references in Victorian and Edwardian newspapers and magazines to the 'procession' on Derby Day from London to Epsom, and its return in the evening.

The *Illustrated London News* published a series of sketches in 1844 to show scenes on the Epsom road on Derby Day, the first scene being a view of racegoers passing the Elephant and Castle pub. Many memories of the Elephant published in the *South London Press* in 1957 refer to Derby Day; 'And what a happy memory is Derby Day at the Elephant – waiting to see the people coming back'. The writers were children at the end of the nineteenth century, and probably poor children, too. They would therefore have had hopes that they might receive some money thrown from passing horse-drawn vehicles, especially of course if the passers-by had received 'winnings' themselves; but otherwise, watchers of the procession, whether children or adults, regarded it simply as an entertaining spectacle. Mrs M. Gaydon recalled: 'We used to stand by the fountain at the Elephant to see the people come home from the Derby in four-horse coaches, brakes, pony traps with the donkeys wearing women's white lace drawers'. Mr H. G. Skinner had similar memories: 'I remember the Elephant 60 years ago – watching the hour long Derby procession. There were the coster-carts, donkey carts, brakes – with four horses – and some with large sticks of rhubarb as sunshades. Some of the horses wore ladies' drawers on their front legs'. There was general agreement in 1957 that the greatest Derby Day had been the one in 1896, when the winning horse was Persimmon, owned by the Prince of Wales (later King Edward VII). The celebrations that day were heartier than they had ever been.

Above: The procession to Epsom on Derby Day, 1844, including the Elephant and Castle pub
(at the top).

Opposite page: An engraving of Mr Emidy driving his twenty-eight horses to Greenwich, past
the Rockingham Arms in 1845.

Mr Emidy's Twenty-Eight Horses

The Elephant and Castle was the setting of many a special occasion, usually the starting point of a feat involving pedestrians, athletes or horses. Many, if not most, of these occasions were promoted by wagers. This was the case in May, 1844, when Mr Emidy, 'master of the horse' to Astley's Amphitheatre at Waterloo, drove twenty-eight horses in fourteen pairs to Greenwich and back, within a specified time. The feat was performed via London Road and New Kent Road. The accompanying illustration shows the extraordinary 'vehicle' passing the Rockingham Arms.

London may always be full of pedestrians, but in the nineteenth century, Pedestrian with a capital P was reserved for those who walked enormous distances, especially within a set time. The Elephant and Castle to Brighton was one such route. We must not forget Dickens's fictional David Copperfield, who walked from near the Obelisk at St George's Circus to Dover, to plead with his aunt, Betsey Trotwood, to rescue him from the clutches of the Murdstones.

The Ministry of Sound

This is one of the Elephant and Castle's best-known and successful businesses, which is situated in Gaunt Street off Newington Causeway. It was set up in 1991 by James Palumbo, the son of Lord Palumbo. At that time, the vicinity of its premises was semi-derelict and the 'superclub' with its twenty-four-hour licence was suitably tucked away. But a proposed development on the adjacent island site between Gaunt Street and Southwark Bridge Road is now a great threat to the Ministry of Sound. A forty-one-storey block of flats is intended, and the chances of residents objecting to the club would be high. It is a matter which is clearly reminiscent of the Imperial Gardens case in Camberwell a few years ago.

7

Shops

Tarn's

The picture to the right shows the main crossroads at the Elephant early in the twentieth century. The view looks north from Newington Butts to Newington Causeway. The pedestrian island in the foreground is placed in the roadway where Newington Butts begins. To the right, beyond the people standing on the pavement, rose the great Elephant and Castle pub that presided over the scene.

All manner of vehicles may be seen. Four of the London County Council's electric trams, introduced in 1903, make their way across the junction. On the right, one horse-bus has emerged from New Kent Road, and another is heading for Walworth Road, behind the Elephant and Castle pub. Pedestrians cross everywhere. And many of them would have been aiming at Tarn's, the light-coloured pile to the right of centre in the background. This was a huge department store, already big in the mid-1800s, but occupying much of the block in which it stood, with a long frontage to New Kent Road as well as Newington Causeway.

The *South London Press* reported in 1871 that 'all the bewildered people in town find their way to the Elephant and Castle. All the nervous ladies in search of TARN'S ... are plumped down there, and left gazing helplessly across the road, which might be the English Channel for any power they have of crossing it, unless piloted over by our friends in blue'. You have to remember that in 1871 roads were very different from those we have today. Their surfaces could be quite rough, and they were certainly liberally covered in horse droppings. The visitors were drawn to Tarn's from far and wide by its range of stock of household goods and clothing. Poorer local folk could only look in wonder through the windows. In 1957, when the *South London Press* ran a series of Elephant memories, one reader recalled, 'Many was the time, with other Walworth kids, that I pressed my nose to the windows of Tarn's, a wonderland at Christmas.'

It is telling that when there were threats of riots and looting in London in 1886, Tarn's was a rumoured local target. *The Times* reported on 11 February 1886: 'Yesterday London from one end to the other experienced another sharp spasm of

The Headway and Newington Causeway in their Edwardian heyday, with Tarn's store to the left (with the long blind).

alarm with respect to rioters, and from the heart of the City to the far off suburbs preparations were made to meet bands of ruffians stated to be on the march'. It sounds remarkably like the London of August 2011. A crowd of rioters was expected at the Elephant from Greenwich, Deptford and New Cross, and the area's shops were all quickly closed, Tarn's especially. A large force of police, on foot and mounted, later broke up the crowd that gathered at the junction.

The Elephant and Castle was generally notable for its shops at the beginning of the twentieth century, and Tarn's was by far the grandest of these. In its heyday, it occupied Nos 165–173 Newington Causeway and Nos 5–21 New Kent Road, forming a huge frontage that was broken only by the Rockingham Arms Public House on the corner. It would be no exaggeration to call the main building a palazzo. It also owned large warehouses and workshops at the back of the same block, towards Rockingham Street and the railway line. In common with department stores elsewhere in London, its mostly young assistants lived in lodgings close by, as may be seen, for example, in the census returns of 1891. It was a remarkable business empire.

The founder, William Tarn (1816–75), came from Muker in Swaledale, an attractive village in what I consider the most impressive of the Yorkshire Dales. He was the son of a land agent. He moved to London and set up a linen draper's at Nos 259–261 Walworth Road. The business succeeded, and he moved it to grander premises in Newington Causeway, gradually expanding and rebuilding until he owned a large part of the entire block. In 1849, he already occupied No. 2 Newington Causeway and Nos 2–5 (consecutive) New Kent Road. It was a department store equal to many in the West End and was promoted as 'complete house furnishers'. It arranged frequent sales and issued incessant advertisements. As a result, it attracted buyers from well beyond

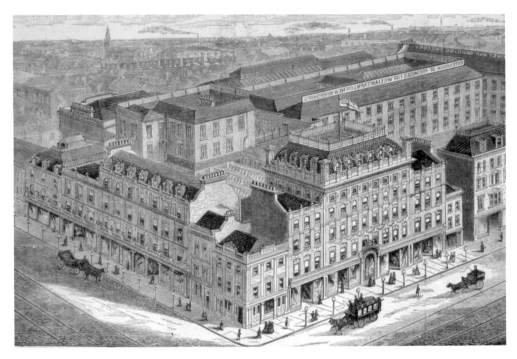

The huge premises of Tarn's, comprising a substantial part of an entire block fronting Newington Causeway and New Kent Road.

the immediate district. A goods delivery service was set up that listed far flung parts of London such as Chislehurst, Worcester Park and Stoke Newington.

A view dated March 1851, shows the premises on either side of the smaller, pre-1888, Rockingham Arms. In the New Kent Road, a Tarn & Co. cart with one horse is being loaded with goods. Women wearing what the world calls bonnets but which were known at the time as 'caps' (see Mrs Gaskell's *Cranford*, published in 1851–53) are entering Tarn's by the main entrance or are walking along the pavement. The façades to both Newington Causeway and New Kent Road have flat pilasters to divide them into bays. Above the shop windows there are very low balustrades, interspersed on the New Kent Road side with urns in line with the Corinthian pilasters below. A generation later, lamps were placed by the kerb along the two frontages. An advertisement for the Spring Season of 1877 lists thirty-two departments, including silks, velvets, mantles, parasols, baby linen, bedding, mourning and cretonnes. On the left-hand side of the main façade in Newington Causeway, there were the Drapery and Mourning Entrances; and to the right, the Dresses Entrance and the Hose, Lace, Haberdashery, etc., Entrance. New Kent Road had its own departmental entrances (*see plan*). The premises stretched along the backs of the neighbouring shops going north along Newington Causeway, almost to Rockingham Street. By Edwardian days, a very long single sun-blind was in position along the main façade.

Tarn's had many sales of stock, comparable with those at the great store of Jones & Higgins in Peckham. Sometimes, these sales were of stock bought when another business

was closed through retirement or death, or following bankruptcy. An advertisement in the *South London Press* of 16 August 1879 offered, 'Carpets. Sale of the stock of the old-established house of Messrs. Russell & Co., 10 to 15, Leicester Square, W.C.'. This stock had come from the executors of R. Russell, deceased. In looking at big Elephant businesses such as Tarn's and Hurlock's, it is natural to think of easy commercial success. There were in fact many failures of firms due to strong competition, and the stocks of these failures would often end up in sales at Tarn's.

The founder died on 22 January 1875, in his 59th year, and is commemorated by a monument in Nunhead Cemetery. It also refers to his wife, Lois Anne Tarn, who had died in 1869. The second William Tarn (1842–91) took over the business, and it then reached its peak. He owned a country house at Chertsey and a town house at Lancaster Gate near Hyde Park. His eldest son, William Woodthorpe Tarn (1869–1957), became an eminent historian of ancient Greece and was knighted in 1952.

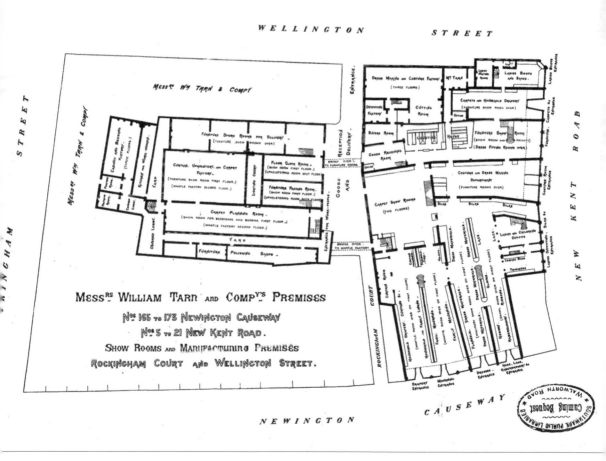

A ground plan of Tarn's retail premises, showing departments.

Tarn's passed into the hands of Isaac Walton & Co. before the First World War, but remained a significant store until it was bombed on 11 May 1941. The site featured as No. 38 in the wartime series of *The Evening News*, entitled *Hitler Passed This Way*, which recorded destruction in the Blitz and afterwards. Fortunately, there was no loss of life in this case.

In the heyday of the Elephant's shops, pubs, theatres and music halls, Tarn's stood out a mile. The easy availability of transport and the junction's place on everybody's journey made the old Elephant thrive, and never mind the congestion.

There is still a Tarn Street, running off Rockingham Street next to the railway viaduct. Until 1892, it was named Wellington Street. In the nineteenth century it ran into New Kent Road.

Rabbits's Shoe Factory & Shop

Tarn's may have been the biggest and grandest of the Elephant's businesses, but the firm of Rabbits on the diagonally opposite corner of the junction seems to have been the one about which people talked the most. In the memories published in the *South London Press* in 1957, it easily led the field. Mrs Hildah Orford called it 'the greatest wonder of the Elephant'. It was clearly a substantial business, but the striking aspect of the memories is that it served as a centre of social life.

The founder of the firm was Edward Harris Rabbits, who was born at Frome in Somerset around 1818. He set up a shoe factory on the corner of Walworth Road and York Street (later Browning Street). He declared in 1847, 'E. H. Rabbits, has not the slightest doubt but that in the course of a few months at most, he will be designated and known as the Cheapest, Best and most Durable Boot and Shoe Maker in the Metropolis'. There is no doubt that his business rapidly expanded. He soon built up a chain of eleven branches, which were run from No. 60 Newington Causeway. An advertisement listing all these premises states that 'Until the Larger Premises are completed near the Elephant and Castle, Newington', the factory would continue to be in the Walworth Road. In the mid-1800s, Walworth Road was still divided into named terraces, so the firm's first factory was properly said to be at Nos 1 and 2 Crosby Row. Rabbits himself was listed there in the census returns of 1851, employing ninety men and eighty-five women. He had married Mary Anne in 1840, but no children are listed in 1851 or later. In the census returns for 1841, an Edward Rabbett [sic], aged twenty-three, appears in the parish of St George, Hanover Square, as a shoemaker, with a wife named Maryam [sic]. This is almost certainly Edward Harris Rabbits. He then appears in a directory of 1845 as a leatherseller at No. 20 Sloane Square in Chelsea.

The new factory was built on the site of the Old Building of the Fishmongers' Almshouses, on the corner of Newington Butts and St George's Road. The property was named Elephant Buildings and was later numbered Nos 2–14 Newington Butts. It consisted of a six-storey block, with nine bays fronting St George's Road, and five bays facing Newington Butts. To the south of this block there was a four-storey part, which was six bays wide. This part was labelled 'Leather Warehouse'. Spurgeon's Tabernacle

was the next building to the south. It was a tribute to Spurgeon's fame that Rabbits put 'Near the Rev. C. H. Spurgeon's Chapel' under his own address, despite having such a substantial block of buildings, most of which faced the Elephant and Castle junction. Above a doorway on the street corner, there was the inscription, 'Established 1846', which must have been the date when Rabbits set up his business at Crosby Row in Walworth Road.

E. H. Rabbits died on 29 October 1874, aged fifty-six. The business nevertheless continued to be run by the founder's relations. William Rabbits, his brother, who was variously described as 'boot upper manufacturer' and 'currier, and boot and shoe manufacturer', was also born at Frome, and seems to have gone into the leather and shoe trade in London separately. For many years he lived in Chelsea. His business address was long given as St Thomas's Works, White's Grounds, Bermondsey, and eventually also as Elephant Buildings, Newington Butts, after Edward Harris Rabbits had died. In his later days, he lived at The Hall, North Dulwich, where he died on 15 October 1878. Two of his sons, William Thomas and Charles Joseph Whittock, appear in documents. Charles secured the Freedom of the City of London as a member of the

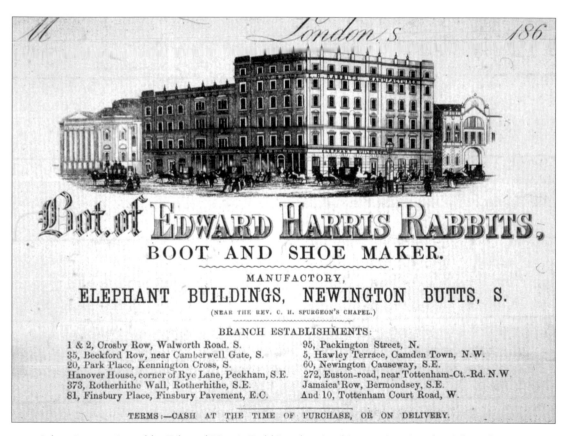

Advertisement issued by Edward Harris Rabbits, showing his premises (on the right) adjoining the Metropolitan Tabernacle (on the left).

Leathersellers' Company in 1878, and is described as 'of St. Thomas's Works, White's Grounds'. This shows that he had entered his father's business. William Thomas and Charles were both born in Chelsea, as was a third son, Edward Harris (1851–1914), who is not mentioned in the published sources used for this book.

The *South London Press* for 1 December 1866 reported that Edward Harris Rabbits had laid the foundation stone of the Methodist New Connexion New chapel in King Street, Old Kent Road, on 26 September. The cost of the building was largely to be borne by him. It replaced a building which had been run since 1862 in connection with Brunswick Chapel in Great Dover Street. One of those attending the ceremony in 1866 is listed as Mr W. Rabbits, probably Edward's brother, William. This is yet a further instance of successful local businessmen in Victorian Southwark supporting one of the Free Churches. The Methodist New Connexion is generally considered to be a rather elevated body in social terms.

In the early twentieth century, the business became part of the well-known shoe firm of Freeman, Hardy & Willis. The premises at Newington Butts were listed in directories under Rabbits & Sons Ltd. until 1912 inclusive; from 1913 the entry is for Freeman, Hardy & Willis.

This firm was still running the Elephant premises when the Second World War began. Two years later, on 11 May 1941, the premises were destroyed by bombing. A picture in the collection of the London Fire Brigade shows the building on fire. The ruins were demolished. The London County Council's redevelopment two decades later threw a fair part of that corner into the roadway. On the rest the London College of Printing was built; it has since been renamed the London College of Communication.

Hurlock's

Hurlock's was a huge business at the Elephant, but it did not have a huge building. Instead of a palazzo like Tarn's, it operated from up to twenty-four shops on both sides of Walworth Road. Their exact street numbers seem to have varied a little from time to time, but they clearly amounted to a very considerable enterprise.

It was founded by William Hurlock (1840–1925), whose business was broadly similar to that of Tarn's: drapery, furniture, clothing, hats and shoes. He quickly made his fortune and established himself in Ver House at St Alban's in Hertfordshire. He served as that town's mayor in 1887/88. In religion, he was a Baptist; it is notable that he always advertised in the *Walworth Road Chapel Magazine*. William was in charge of his business until 1920; subsequently, there were three partners with different surnames.

Two pictures of King George V's Silver Jubilee procession in 1935 show in the background some of Hurlock's shops in that part of Walworth Road between the railway bridge and the Elephant and Castle pub. One shows No. 57 (general household and furnishing drapery) and Nos 61–63 (mantles, costumes, furs and mourning), just south of the pub at No. 55, on the eastern side of Walworth Road. The other picture shows No. 71 on the same side, which offered men's bespoke tailoring, plus a view back to the Elephant and Castle pub in the background.

King George V and Queen Mary process along Walworth Road, 1935, past Hurlock's shops.

Upton's

This was a major factory and shop, built by Fred Upton, hat manufacturer, in 1883. His premises stood on the corner of London Road and St George's Road and were known as 'Upton's Corner' for two or three generations. They had an ornate façade, with Classical window surrounds, a balustrade at the top interspersed with urns, metal cresting on the roof and big lamps hanging over the ground floor. It needs to be stressed that the premises served as a factory and not merely as a big shop. The making of things was a notable feature of the Elephant's late Victorian economy.

Upton had a particular line in silk hats. His 10s 6d (52½p) silk hat was a speciality, 'combining high quality with low price'. It has to be said that 10s 6d in the 1890s was half the weekly wage of many Londoners, and some farm labourers in the late nineteenth century were earning only the cost of an Upton's hat. But there was a special compensation if you could afford one. *Camberwell and Peckham Illustrated* remarked, in relation to his silk hats, 'the lightness and efficient ventilation being notable features', and added, 'If it is true, as some authorities say, that baldness results from heavy and ill-ventilated hats, those supplied by Mr. Upton will be a boon'. At about the time these remarks were published, in the mid-1890s, Fred Upton removed his headquarters to No. 61 High Street, Peckham.

The site at Upton's Corner was eventually used to build Burton's store in 1934, which is discussed below.

WILLIAM WAINE'S
FURNISHING WAREHOUSES,
3, 4 & 5, Newington Butts,
Manufactories, Francis Street and Hampton Street.

Tapestry Brussells Carpets, 2s. 4½d. per yard.

EVERY ARTICLE WARRANTED.

All Goods purchased must be paid for on or before delivery.

Furniture and Property of every description Warehoused.

Advertisement for Waine's upholstery business, Newington Butts.

Waine's

This was a furniture and upholstery business, located at Nos 131–139, Newington Butts. It was a substantial firm which was in business for some generations, but its particular interest to the author of this book is that one of the family was devoted to local history. He was George Wheatley Waine (died 1944), who was the eldest son of the main driver of the business, William Waine. Although he was listed in the 1881 census returns at the address of the family business, together with his two younger brothers, he was described as an 'analytical chemist'; by 1911, he was listed as 'Gentleman'. G. W. Waine was tireless in collecting material about the church of St Mary, Newington, its schools and almshouses, and related subjects, which may now be seen in the local history library. It is undoubtedly the case that many of the details he recorded would be otherwise unknown. He is hereby made an honorary patron of this book. William Waine had been born at West Layton in Yorkshire. In the census returns for 1851, it states that he employed forty-seven men and twelve women.

Sandow's Health and Strength Cocoa

The fine buildings at Nos 5–21 New Kent Road, which formed a major part of Tarn's premises for some decades, were taken over in 1911 by Eugen Sandow (1867–1925), a famous bodybuilder and later a maker and vendor of what we would today call health foods. He was born at Konigsberg in East Prussia. He became a performer in a circus

and eventually came to London as a showman. He graduated to being a champion bodybuilder and took part in the first major bodybuilding contest at the Royal Albert Hall in 1901. He was a sensation in music halls, displaying his powerful physique naked except for a fig leaf carefully glued in place.

It is reported of his performances in the music hall and elsewhere that among his feats, he 'lifted a full-grown horse high above his head' and 'tackled a 530 lb lion that had recently eaten his keeper for supper'. After his performances, 'privileged guests including King Edward VII would go backstage to see this physical phenomenon close up, often accompanied by awestruck wives who were encouraged to run their ungloved hands along Sandow's legendary biceps'.

In New Kent Road, he set up a business to make and sell what he called 'Sandow's Health and Strength Cocoa'. The premises amounted to 140,000 square feet and were described as 'a palatial block'. This was no exaggeration. He promoted the cocoa as a 'Drink-Diet'. 'Not that it is medicated cocoa', he firmly stated, adding, 'It is an absolutely pure cocoa, from which the excess of insoluble fats and indigestible waste material is eliminated, and the percentage of albumenoids is thereby proportionately increased'. He described albumenoids as 'the most valuable of all tissue-building elements'. No doubt, 'tissue-building' was what the cocoa's buyers hoped for most. He claimed that his cocoa was finely ground and easily digested. It was sold in ¼ lb, ½ lb and 1 lb tins, the largest one costing 2s 6d (12½p). The tins had 'Elephant and Castle' marked on them.

Sandow also made 'Sandow's Health Food Baking Powder' and Vanillin sugar. The cocoa nevertheless remained in centre stage. A new factory was opened at Hayes in Middlesex in 1913. It would appear, however, that interest was rather short-lived and that he overreached himself with the cocoa and his other health-foods, for the Elephant operation was wound up by the middle of the First World War. The Hayes factory continued under other hands and eventually passed to Nestlé in 1929.

An English Heritage blue plaque in honour of Eugen Sandow was unveiled in 2009 at No. 161 Holland Park Avenue, where he lived and died. Chris Davies, Sandow's great-grandson, spoke at the unveiling.

Burton's

Sir Montague Burton, who died in 1952, was notable for building up the largest tailoring business in the country. His first shop was opened at Chesterfield in 1903. At his death, he presided over 616 shops and 14 factories. The substantial premises at the Elephant and Castle were opened on 9 February 1934, at Nos 67/68 London Road, on the corner of London Road and St George's Road. This site had long been 'Upton's Corner'. The building amounted to 16,394 square feet. It followed the standard design of Burton's stores; you can see a survivor opposite St Alfege's church in Greenwich.

Burton's remained at the Elephant until the later stages of the London County Council's redevelopment. It was ironic that this was its fate, because its construction was declared to be a symbol of the area's revival after the earlier London County

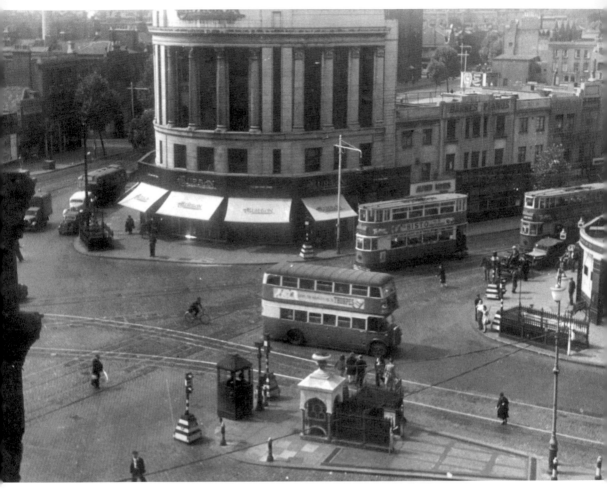

The main junction in the 1930s, with Burton's in the background, and the police box and fountain in the middle of Newington Causeway in the foreground.

Council Clearance Scheme had blighted it for some years. The scheme had been dropped by 1934. The article in the *South London Press* reporting the new shop was entitled 'The Elephant – and the Tailor's Castle'. It lacked the ornate nobility of Tarn's premises, relying for effect on a row of super-columns high up on the façade. It was faced in Empire stone and was originally floodlit. The site was later used to build Perronet House.

Further Businesses

The considerable success of several large and well-known businesses at the Elephant and Castle and the more pedestrian progress of many smaller ones must not make us think there were no failures. On 8 September 1879, at the Bon Marché, Brixton, a sale

Robert Baker's iron and brass bedsteads, sold at Nos 46–50 Walworth Road, were proclaimed to be strong enough to support elephants.

began of Donald Macgregor's stock from Nos 107–109 Newington Butts, following his bankruptcy. Macgregor had opened an 'Additional New Saloon and Show Room' in 1876 and was offering a 'Great Display of Evening and Ball Gowns'. The dresses had rather grand names: The Buckingham, the St James, the Princess of Wales and the Eglantine Robe. He had evidently over-stretched himself and misjudged the market. His offerings were impressive, but the local market was clearly full of competition.

Many businesses depicted their premises on their advertisements and in their invoices. Robert Baker's leaflet for his bed shop showed not just the shop front but also elephants standing on his metal-framed beds, which were allegedly strong enough to support them. He traded at Nos 46–50 Walworth Road, near Hurlock's. In 1961, the Felston (Furniture) Co., Ltd ran the Elephant Sleep Shop at No. 81 Walworth Road.

8

Pubs & Restaurants

The Elephant in its heyday offered countless places to eat and drink. As I am fond of likening John Farrer's Elephant and Castle pub of 1898 to a great ocean liner in harbour, it also has to be said that it was surrounded by many further vessels. The Elephant and Castle may have been the flagship, but its competitors were certainly substantial. In the big junction itself, it faced two large competitors: the Rockingham Arms on the corner of Newington Causeway and New Kent Road; and the Alfred's Head, at the south-western end of Newington Causeway and the south-eastern end of London Road. They were typical Victorian pubs which 'took the corner' and greatly added to the townscape. Just as the Elephant and Castle made up for its constricted site by standing very tall, with turrets and a dome, so the Rockingham Arms had a prominent corner turret to announce itself, between the two ornate ranges of Tarn's great department store.

The turreted Rockingham Arms was built in 1888 under W. W. Goosey, well after its neighbour the department store had been grandly redeveloped. This building lasted until 1960, when the London County Council reshaped the whole area. In its later years, it sported a large Guinness clock, which was a well-known feature of the junction in the mid-twentieth century. In the earlier years of the century, it had the word 'Bovril' displayed across the upper part of its façade.

The Alfred's Head was closed on 16 December 1961, and was demolished in March 1962. Its formal address was No. 140 Newington Causeway, but it seemed to stand equally in London Road. From 1906 it had the Bakerloo Underground station as a neighbour, and a little later the offices of the *South London Press* in the station's upper storeys. The Alfred's Head was decidedly ornate, very unlike today's plain and bland structures. The old pub had fluted pilasters, with prominent capitals on the first floor, elaborate gates on the ground floor, much incised decoration, and a set of exuberant lamps, to say nothing of the clock at the top. It is an interesting detail of the clock that it was inscribed 'Tree, Great Dover Street'. This reminds us that Southwark had a large manufacturing economy in Victorian days and beyond. Stephen Tree made clocks and watches in the Borough, and traded in Walworth Road.

Postcard showing London Road from the Headway, with Upton's Corner's on the left and the Alfred's Head pub to the right.

The Flying Horse and Colonel Despard

The Flying Horse stood at No. 78 Walworth Road, on the west side, north of the railway bridge and on the curve into Draper Street. Originally, the site was known as No. 19 Crown Street. It was rebuilt in 1888. This was a typical date for a Victorian rebuilding (the same as the Rockingham Arms) and ten years before the Elephant and Castle itself.

The Flying Horse briefly became notorious for being one of the places where Colonel Despard and his conspirators were detected in 1802. The aim of the conspiracy was no less than the killing of King George III and the overthrow of his government. Edward Marcus Despard (1751–1803) had come from a military family; one of his brothers, John, became a full general. Edward himself had been an officer in the British army with a highly creditable record. He was stationed in the West Indies, where he met and greatly impressed the young Nelson. He was then sent to lead a force to the Bay of Honduras (also known as the Mosquito Coast). Today it is the Commonwealth country called Belize. There he won the Battle of the Black River in 1782, and was afterwards appointed Superintendent of the Bay of Honduras; in later years, the equivalent title would be Governor of British Honduras. For that era, he was remarkably even-handed between Europeans and locals, but unfortunately for him the Europeans eventually complained to London.

Despard was recalled in 1790 and never prospered thereafter. He was held in the King's Bench Prison in Borough Road, Southwark, in 1792–94 for debt and then – fatally – he began to associate with the London Corresponding Society and the body called 'United Englishmen'. In those feverish days of the French Revolutionary and Napoleonic Wars, he came under great suspicion and, due to the suspension of habeas corpus, he was held in prison from 1798 to 1801. When he was released, he turned to an actual conspiracy. The conspirators met at both the Flying Horse at the Elephant and at the Oakley Arms in Lambeth. They were arrested in November 1802, and first appeared in court at Union Hall, Southwark, on the 17th. The charge was no less than treason.

Upon the subsequent convictions of Despard and six fellow conspirators, they were sentenced to be hanged, drawn and quartered. In the event, they were only publicly hanged and beheaded on 21 February 1803, on the roof of the gatehouse of the Surrey County Prison, Horsemonger Lane (the present Harper Road), a quarter of a mile north of the Elephant. The Life Guards patrolled Southwark's streets that day from 6 a.m.; the executions took place just before 9 a.m. Despard's body was buried (rather strangely) in the burial ground on the north side of St Paul's Cathedral. His fellow-conspirators were all buried in the vault of the Revd Mr Harper's Chapel in London Road at the Elephant, just north of what became Skipton Street.

The Gibraltar

The Gibraltar certainly deserves some attention. It used to exist at No. 35 St George's Road, on the corner of Elliott's Row. After it was closed, its building was used for a few years as a Thai restaurant, and then it laid empty until its demolition in 2013.

This part of St George's Road was first developed at the end of the eighteenth century, and both the pub and the name of the side street recall the great siege of Gibraltar from 1779 to 1783, when French and Spanish forces tried unsuccessfully to take the Rock. General George Augustus Eliott [not Elliott] (1717–90) was the defender of the Rock as its Governor from 1777 until his death; he later became Lord Heathfield. For a few generations, well into the nineteenth century, the siege was the subject of many spectacles or tableaux in pleasure gardens. Bermondsey Spa Gardens under Thomas Keyse offered such events just a few years after the siege. The Surrey Gardens in Walworth, under Edward Cross, used its large lake with a promontory to set up a Rock on the latter, with naval vessels attacking it, all aided by fireworks and music. Note that the name of the side street does not follow its hero's spelling.

At the other end of St George's Road, at St George's Cathedral, we are again reminded of Gibraltar. Peter Emmanuel Amigo (1864–1949), a long-serving Catholic Bishop of Southwark (1904–49), with the personal title of archbishop (before the diocese had become a province of the Catholic church), was a native of Gibraltar. Previously, from 1901 to 1904, he had been the Rector of the Mission in Walworth which became the English Martyrs' parish in Rodney Road. The cathedral's hall and a block of flats in

Opposite page: The Silver Grill Restaurant, 'two doors from the Horse Repository'.

ELEPHANT & CASTLE

SILVER GRILL,

CAFÉ & RESTAURANT

14, NEW KENT ROAD

Next Door but one to the HORSE REPOSITORY.

SOUPS
FISH
JOINTS
POULTRY
ENTREES
PASTRY
AND
VEGETABLES

At any Minute during the Day (including Sunday)

COLD DISHES
AND
CHOPS & STEAKS

ALWAYS READY.

Chocolate and Coffee a la Française

LADIES' PRIVATE DINING ROOM UP STAIRS

The Proprietor guarantees that every Article is of the First Quality.

Westminster Bridge Road nearby are named after him, and his monument may be seen in the north nave aisle of the cathedral. One of his successors, Michael Bowen (born in 1930), Archbishop of Southwark from 1977 to 2003, was also born in Gibraltar.

Restaurants

The Silver Grill at Nos 12–16 New Kent Road was described by its late Victorian proprietor, Henry Briggs, as a 'Cafe, Restaurant, Coffee House and Cigar Divan' [a divan was the name for a cigar shop or for a smoking room attached to one]. Rather improbably, it was advertised as 'two doors away from the horse repository'. No doubt you followed your nose. Its customers, one might think, would have agreed with the petition by undergraduates at Cambridge in 1871 for 'properly cooked meat from the usual joints of recognised animals'. In fact, there was indeed a link between the restaurant and the repository. The census returns and records of birth registrations show that Henry Briggs was the brother of George Briggs, the repository's proprietor. They were the sons of a Newington fishmonger.

The Imperial Dining and Tea Rooms on the corner of Skipton Street and Southwark Bridge Road offered hot joints at 12 noon, 1 p.m. and 2 p.m., and stressed 'All tea fresh made. No urns'. 'First-class dining and smoking rooms' were available on the first floor.

In London Road, at No. 71, which has been part of the site of the Bakerloo Line Underground station for more than a century, there stood the Electric Dining Rooms. For a few years at the very end of the nineteenth century, this establishment was run by Tom Garrett; and yet some sixty years later, when the *South London Press* published a long series of reminiscences of the Elephant, it was recalled by many people. No. 71 was two doors north of the Alfred's Head pub on the eastern side, in the short block before Skipton Street. One correspondent in 1957 said of Tom Garrett: 'He was a strange boss to work for. One day he said he was going out for "a couple of minutes". He came back half an hour later, having got married to one of his staff'. I duly looked him up in the General Register Office and found that Thomas James Garrett, aged thirty-four, Eating House Keeper of No. 71 London Road, married Louisa Roy, aged twenty-three, also of No. 71 London Road, at St George the Martyr church in Southwark on 24 January 1898. St George's church would have been ten minutes' walk from No. 71 London Road. The correspondent also stated in 1957 that Tom Garrett was still alive then. This was also true, for he died at Streatham in 1959, aged ninety-six, and was described as a 'retired caterer'.

9

Railways

The London, Chatham and Dover Railway

The first railway station to be built at the Elephant and Castle served the main line London, Chatham and Dover Railway. This name had been given in 1859 to what had been the East Kent Railway, serving the Medway towns and Faversham, and which was rapidly extended to Canterbury in 1860 and Dover in 1861. In common with all the major Victorian lines, it then sought a link with London. This link was labelled the Metropolitan Extension Line and it included the track between Herne Hill and Blackfriars. Parliamentary powers were granted in 1860 and it was built in 1862–64. As a result, the company became the first to have a station in the City across the river, in 1865. The London, Chatham and Dover line later had Joseph Cubitt (1811–72), son of the distinguished Victorian civil engineer, Sir William Cubitt (1785–1861), as its engineer-in-chief, but this came after its initial development.

The line was carried through Camberwell, Walworth and Southwark on a viaduct, and so the station at the Elephant and Castle could not have a conventional ground-level façade with a central entrance. Instead, it presents a screen wall to Elephant Lane at the height of the platforms, which is nevertheless clearly representative of the mid-Victorian age. These days, however, more people arrive at the station through the Elephant and Castle Shopping Centre on the other side. It is a rule of thumb that a railway built on a viaduct would bring an area down socially, whereas one built in cuttings or under 'cut and cover' arrangements would have a neutral effect. Comments about the western side of Walworth Road in the 1860s make it clear that some people resented the intrusion of the viaduct and the social damage they judged it had brought. It has to be said in favour of the opposite view, however, that many people had begged for a Walworth station in that area as offering a better form of transport than the existing horse-drawn buses.

The Elephant and Castle station was opened on 6 October 1862, as the northern end of the new stretch of track from Herne Hill, with one intermediate station at Camberwell. A further station between there and the Elephant was opened on 1 May

1863, under the name of Camberwell Gate; it was reached from the north side of Beresford Street (John Ruskin Street from 1937). It was renamed Walworth Road station in 1865. Two extra lines were then added on the western side of the viaduct and were in use from 1 March 1866.

We are used to hearing people these days grumbling about trains. There always seems to be an assumption that they were once more punctual, comfortable, better-staffed and smarter. It is often thought that the Victorians enjoyed far better services. In fact, the Victorians also grumbled, and in Southwark they notably did so about the London, Chatham and Dover Railway. Walworth Road station was particularly lampooned, but the whole line came in for some stick. A page of cartoons published in 1876 was entitled *Walworth Station or, the Chatham and Dover Shoot*. The first sketch showed an engine attached by a chain to a tortoise. Another showed two passengers carrying beds on their backs, 'cos we wants to wait for the next train'. And a third depicted 'one of the obliging officials', who was clearly annoyed by having to drop his newspaper for a moment to serve a passenger, and saying, 'Come 'ere and let's clip yer ticket'.

The Chatham line was contrasted very unfavourably with the fashionable Brighton line, which was run by the London, Brighton and South Coast Railway. In Oscar Wilde's *The Importance of Being Earnest* (1895), there is the famous scene in which Lady Bracknell questions the poor chap who had been found as an infant in a bag at Victoria station. He tried desperately to make himself sound more respectable by saying that he had been found on the station's Brighton side rather than the Chatham side!

Coal Yards

London depended on coal in the past, and its distribution was a significant industry. There is a well-known print of the Pool of London in Georgian times, in which the unloading of coal is clearly the overwhelming trade in that part of the Thames. It is surprising to find that coal continued to come to London chiefly by water long after the railways had been built. In 1938, 6,951,000 tons of coal came to the capital by rail, but a stupendous 14,643,000 tons came by water. 'Sea coal', as it was called in the 1600s and 1700s, remained dominant throughout.

At the Elephant and Castle, however, the coal trade centred on two railway coal depots. They were both attached to the line that had been built by the London, Chatham and Dover Railway in 1862–64, and they were 'foreign depots' in railway parlance, meaning that they were run by companies from regions elsewhere. One of these companies was the Great Northern Railway. In 1864 it contributed to the costs of the London, Chatham and Dover Railway's Metropolitan Extension, and seven years later it leased a coal depot north of Elephant and Castle station, overlooking Rockingham Street. This depot had been owned by Samuel Plimsoll, who is famous for the Plimsoll Line in merchant ships. He had considerable business interests near the Elephant, but was mainly a coal merchant who became interested in the safety of merchant ships after observing colliers plying from the north-east to London (*see Chapter Thirteen, under Samuel Plimsoll*).

The siding in this case was level with the viaduct and was joined to it by points from the down main line. The siding served a row of short stubs, where coal wagons were moved by a traverser. The coal was dropped to ground level by shoots. The Great Northern Railway ran as many as five trains a day to this depot by 1873. By 1954, only one delivered coal.

The second coal depot was far larger. It was located on the western side of Walworth Road, between Steedman Street and Amelia Street. It was opened in 1871 by the Midland Railway, the company that built St Pancras Station. It boasted 30 stubs and no fewer than 113 coal shoots. It underwent reconstruction as late as 1958/59 to allow a capacity of 70,000 tons a year, just before the coal trade was undone by the Clean Air Act. In its later days, there were two sidings that could take forty 16-ton wagons between them, and fifty unloading bays on either side of the traverser. The Midland Railway ran six trains each weekday in 1873. This had declined to two by 1954. By then, the depot had passed to the Southern Region of British Railways from the pre-war London, Midland and Scottish company. The depot was closed in 1973.

The Northern and Bakerloo Lines of the Underground

Whereas South London is notoriously bereft of Underground lines, the Elephant and Castle is blessed with two, which we now call the Northern and Bakerloo Lines. The former was the first long railway line to run in a deep tunnel – the first 'tube' railway – and it was also the earliest electric underground railway in the world. Previously, lines had been built on the 'cut and cover' principle, and used steam engines.

The Walworth Road Coal Sidings, 1957, seen from the viaduct. (*R. C. Riley, The Transport Treasury*)

The City of London and Southwark Subway

The company that built the oldest part of the Northern Line – including the Elephant and Castle – was incorporated in 1884 as the City of London and Southwark Subway Company. The Bridge House mark, that well-known symbol of Southwark, and particularly of St George's Parish, appeared on the company's circular badge. The word 'subway' harked back to the Tower Subway of 1869–70. This short tunnel was built under the Thames near the Tower of London under powers granted by an Act of Parliament in 1868. It was designed by Peter William Barlow (1809–85), who based his ideas on Sir Marc Brunel's pioneering work in boring the Thames Tunnel at Rotherhithe in 1825–43. But memories of that long and costly work made contractors unwilling to get involved, and so the subway was built by Barlow's former pupil, James Henry Greathead (1844–96). He was a significant figure in the history of British engineering and has a prominent memorial in the City, in Cornhill by the front of the Royal Exchange.

Powers were likewise granted to Barlow in 1870 for a longer subway between the Monument in the City and St George's church in Southwark, but no work was undertaken on this scheme, and it was abandoned in 1873. Although the first subway had been built without trouble and money had been subscribed, it was clearly unprofitable. No money was therefore forthcoming for the second and longer subway. The Tower Subway was soon transformed into a pedestrian route. In 1894, when Tower Bridge was opened, it was taken over by the London Hydraulic Power Company for its pipes. In more recent times it has been used for fibre optic cables.

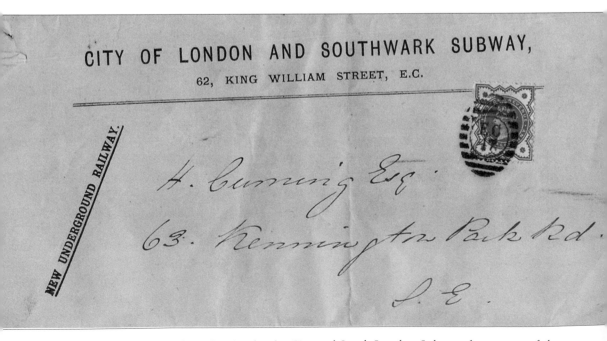

Letter sent to Henry Syer Cuming by the City and South London Subway, forerunner of the Northern Line.

Omnibus Subways to Electric Tubes

Barlow referred to his two schemes as 'omnibus subways', to be operated by cable traction. In the Tower Subway, a carriage holding just twelve people was pulled through the tunnel by a cable powered by a static steam engine on the south side. This method of operating was also the intention in the more ambitious subway scheme of 1884. The original plans included a cable engine house at the Elephant. This was still the intention when the subway's construction began in 1886. However, by the time the line was opened in 1890, electricity had taken over. The company declared a preference in 1888 for 'electrical force, conveyed by continuous conductors', and a contract for electric power was placed with Mather & Platt Ltd in 1889. The system of electric traction employed was the one that had been invented by Dr Edward Hopkinson.

The first Chairman of the City of London and Southwark Subway Company (from 1884 to 1905) was Charles Grey Mott, who had been a director of the Great Western Railway since 1868. Greathead was almost inevitably the engineer, and it was therefore his improved tunnelling shield that produced the first 'tube' line.

The Elephant and Castle was the intended terminus in 1884, but by 1887 the plans for the line included its extension to Stockwell. The first public service in 1890 therefore ran from King William Street in the City to Stockwell. On 7 March in that year, the Lord Mayor of London and further guests travelled from the City to the Elephant, where Greathead explained the line's operation. The line was formally opened on 4 November by the Prince of Wales (later King Edward VII), and the public service began on 18 December. By then the company's name had been changed to the City and South London Railway. The new line had a set of domed stations designed by T. Phillips Figgis, of which Kennington Station is the best visible survivor today. Each station had two fifty-passenger hydraulic lifts. The Elephant and Castle was the deepest original station and had the up and down lines at the same level. There was also a signal box at the station.

Shaken to Bits in Padded Cells

People grumble very readily about public transport, however innovative and useful it may be in contrast to any previous provision. And so a passenger on the City and South London Railway in 1891 complained that 'there is a great tremor so that when I got off I felt shaken to bits'. This is reminiscent of the electric trams being called 'boneshakers' and of letters published in the *South London Chronicle* in the 1860s decrying the horse-buses in Walworth Road. The original thirty-two-seat carriages were popularly known as 'padded cells' because of their upholstery rising to some height, with tiny windows at the top. Indicator boards were provided in these carriages because the windows were too high for the passengers to see the name-plates on the platforms. A surviving 'padded cell' may be seen in the National Railway Museum at York. Three of these carriages, plus a locomotive, made up each train, which therefore offered ninety-six seats. Each locomotive had two 50 horsepower motors. The original fare was 2d (two old pence or less than 1p today) for any distance.

Extensions and Incorporation in the Wider Underground

Extensions were soon planned. Just ten years after the line's opening, a new tunnel north of Borough Station was bored to allow an extension beyond King William Street. The resulting Borough to Moorgate line was opened on 25 February 1900. In the other direction, the line was extended to Clapham in the same year. The last southern addition, to Morden, came on 13 September 1926. The title of Northern Line was adopted in 1937, but long before then the Elephant and Castle had been roped into a London-wide system. The label of Underground had been used from 1907, when lines were in different ownerships. The City and South London Railway was not taken over by the predominant Underground Group until January 1913. This was the company which had been forged by an American entrepreneur, Charles Tyson Yerkes. He formed the Underground Electric Railways Company of London Ltd in 1902. He promoted the Piccadilly and Hampstead Tubes, and took over what became the Bakerloo Line from an earlier company.

The original 'power house' of the line was at Stockwell. From 1915, however, after the line had been taken over by the Underground Group, power was supplied by the new owner's power station at Chelsea. One of the new substations which were built at that time was at the Elephant and Castle.

Some 165,000 passengers used the new line in the two weeks after it was opened. In the first complete calendar year, 1891, the total was 5,363,000. Thirty years later, in 1921, the year's tally had reached 31,827,000. During the whole existence of the original line, from 1890 to 1923, the overall total was 660 million passengers.

Reconstruction of the line began on 8 August 1922 (from Moorgate to Clapham Common), but at night only. It was not until 27 November 1923, that the line was completely closed. This was the end of the original railway, for at the line's reopening on 1 December 1924 it was substantially new. The tunnels at the Elephant and Castle were completely new and the station there was also rebuilt. The trains on the new line consisted of seven carriages which each provided forty-eight seats, making a total of 336 seats in a train, in contrast to the ninety-six back in 1890.

The Baker Street and Waterloo Railway

Unlike the City and South London Railway, the Bakerloo Line was not originally intended to reach the Elephant and Castle. When the Baker Street & Waterloo Railway Company was incorporated in 1893, its southern terminus was to be Waterloo. It was only in the fourth Act of Parliament relating to the line, in 1900, that authority was given to extend it to the Elephant and Castle. The same Act authorised an open-air depot at St George's Circus, which still exists and which runs all the way along Lambeth Road to its junction with St George's Road. The depot's site had previously been occupied by the School for the Indigent Blind, one of the big charitable institutions of the old St George's Fields. The depot was also to house a power station. The subcontract for the Elephant and Castle extension, plus the depot and power station, was granted to John Mowlem.

The major part of the capital behind the project came initially from the London and Globe Finance Corporation, but this firm collapsed at the end of 1900. In 1902,

the railway company was acquired by the Metropolitan District Electric Traction Company. This was run by Charles Tyson Yerkes, the American entrepreneur who had developed public transport in Philadelphia and Chicago. He was to build the Piccadilly and Hampstead Tubes as well as to complete the Bakerloo scheme. Later in 1902, he formed a new holding company called the Underground Electric Railways Company of London Ltd, or UERL. This was the beginning of the familiar label of 'Underground' for all the subterranean railways of London, although it did not start to appear at stations for a few more years. It was to run the greater part of London's tube system until 1933. The London Passenger Transport Board which took control in that year based itself in the UERL's headquarters at No. 55, Broadway, in Westminster. The UERL set up its own power station for all its lines at Lots Road in Chelsea, and so the intended one at the St George's Circus was abandoned and only a substation was built there.

An intermediate station between Waterloo and the Elephant and Castle was authorised by a further Act in 1904. It was originally called Kennington Road but was later renamed Lambeth North. The line from Baker Street to this additional station was opened on 10 March 1906, and the final stretch to the Elephant and Castle followed on 5 August in the same year. *The Evening News* first used the name, Bakerloo, in the heading to its report on the line on 7 March 1906. It caught on, and the line was called the Bakerloo Tube by the UERL, in alliance with its Piccadilly and Hampstead Tubes, which were opened in 1906 and 1907 respectively. As the minimum fare was 2*d* (two old pence, worth less than one current penny), again in common with contemporary lines, *The Evening News* also referred to it as 'a Tuppenny Tube'. The label of Bakerloo Line was not adopted until 1910. By that time, the separate companies for the Baker Street, Piccadilly and Hampstead Tubes had been merged, and so they were thought of as one railway's various lines.

The trains on the new line consisted of six carriages, each 50 feet long, with the first and last motorised, and they could hold 300 passengers between them. This was more than three times the number on the first trains of the City and South London Railway in 1890. The carriages had been made by the American Car and Foundry Company in the USA, and they were then delivered in dismantled form to Manchester. There, they were reassembled and were taken by rail to Camden goods' yard in north London. The final leg of their journey to the depot at St George's Circus took place towards the end of 1905 and was undertaken, rather strangely, by horse-drawn wagons, one carriage at a time. The *Daily Chronicle* described them on 6 March 1906, as scarlet below and yellow above. The colours seem to have been somewhat less bold in reality, a darker red below and a paler colour above. The original carriages had gated enclosures at each end (except where there was a driver's cab), with a central doorway reached from the enclosure. Such gated stock was in use on the Bakerloo until 1929.

The station at the Elephant and Castle to which the new Bakerloo trains ran from 1906 was one of Leslie W. Green's handsome two-storey buildings clad in deep-red-glazed terracotta. It was built at the junction of London Road and Skipton Street (partly on the site of the Electric Dining Rooms). The ticket hall had been prevented from being placed under the Elephant and Castle junction by the stipulations of the Council of the

Metropolitan Borough of Southwark, which had been incorporated in the Act of 1904. The earlier plan of 1900 had had the ticket hall beneath the junction, with subway entrances from all the corners. These would have been the first pedestrian subways at the Elephant if they had been built, but in the event a few more years passed before any were constructed. Most of Leslie Green's two-storey Edwardian stations had further floors added above for commercial use, and this was soon the case in London Road. The entire new building was photographed by the Bedford, Lemere studio on 8 August 1907. The three office floors above the Tube make an attractive building. There are flat pilasters running up all three floors, with banding in stone and red brick. This was a feature to be seen on many contemporary buildings, such as those on the eastern side of the Walworth Road between Liverpool Grove and Merrow Street, and to some extent in the Elephant and Castle pub of 1898. Another common architectural feature of the time is the circular window at the top of the middle bay to London Road. The Skipton Street façade is longer. The doorway to the offices in London Road is now labelled South London House, after the long occupation of the premises by the *South London Press*, and is numbered 70–72.

An electricity substation was originally built for the line in the depot at St George's Circus. This was closed in 1917 and was replaced by one next to the Elephant and Castle station on the side nearer to the main junction. It was a remarkably reticent building, but it clearly seemed to be related to the tube station. The new substation also served the City and South London Railway, later to be the Northern Line. As soon as it was opened in 1906, the Bakerloo line was linked by subway to the City and South London Railway.

Twenty years after the opening of the Bakerloo Line, the question of its extension southwards was first officially raised. In this and later plans, there was usually an extension to Camberwell or Peckham in mind, with an intermediate station in the north of Camberwell, in or near Albany Road. This was the first act in a long-running farce, which has still not finished today. The suggestion of 1926 led to no action. The idea was revived in 1930 and parliamentary powers were obtained in 1931, but the poor finances of the UERL at the height of the interwar depression stopped it from being taken further. A third airing of the proposal came in 1934, to be dropped in the following year. Nothing further happened until 1948, when an extension was announced for construction in 1950–53. But the costs were soon considered to be too high. A fifth attempt in 1957–58 was followed by the lapsing of the powers in 1961. Yet another official proposal to extend the line came in 1964, but 'not as a task of the first priority'. In other words, it was doomed to failure from the start. Then a stronger chance seemed to come in 1969, but by 1974 the case was 'thought to be weak'. The idea has lately had an eighth airing. Will elephants finally fly, I wonder? The *South London Press* commented in 1960: 'There never was a tube in South-East London and never will be'. The proposal at one stage to extend the line as far as Peckham Rye included the possibility of a huge new depot between Peckham and Nunhead. This might well have aroused great opposition, in view of the strong revolt against a tram depot in Peckham in more recent years.

The Bakerloo Line Tube station and the offices of the *South London Press* above, 1960.

Until 1985, the Bakerloo trains still used carriages from 1938. These had distinctive red upholstery and paintwork, and a noble profile. Part of one of them may be seen in the London Transport Museum at Covent Garden. I found them much more comfortable than other Tube trains. From 1989, the line used only 1972 Mark II stock. Also until the 1980s, the original Otis lifts were still in use at Elephant and Castle station.

Jewish History at the Elephant

The Borough Synagogue

Southwark has never been considered a district notable for its Jewish population, and books on Jewish history in London pay little attention to districts south of the river. Nevertheless, the Elephant and Castle area did have a synagogue for more than a century and a half, and it was the one part of the present borough where there was formerly an obvious Jewish presence.

Jews were readmitted to England under Oliver Cromwell in 1655. For a very long time, they were still excluded from large areas of public life, but this was no different from, say, the position of the Quakers and Baptists and so, like them, they were largely confined to trade and commerce. By and large, all such excluded groups prospered in these fields. In London, they came to be numerous in the City, at a time when it was a residential area as well as the country's financial centre. Many of the main financial institutions began their existence in the second half of the seventeenth century. To this day, there is a particularly old and very fine synagogue in Bevis Marks, north of Leadenhall Street.

Later, as City residents began to disperse to other districts of London, the Jews were among them. Some came south of the river, which was close at hand and offered, around 1800 at least, some very respectable new residential areas. They could still work in the City and perhaps still worship there as well, but live in the new Georgian houses in spacious surroundings in Walworth and St George's Fields. Despite the maintenance of old connections with synagogues in the City, which was important in relation to their burial grounds, there was inevitably some desire to worship more locally. As early as 1799 a small synagogue was opened in the yard of a house in Market Street, which is the present Keyworth Street just north of the Elephant. Nathan Henry was its founder and he maintained it until he died as late as 1853.

In 1823, however, a separate synagogue was set up in Prospect Place, a part of the present St George's Road. Back in the eighteenth century, this had been completely open land: the southern edge of St George's Fields. It ran in parallel with Nathan Henry's

establishment for a generation. In this period, from the evidence of local rate books, it would seem that there was a sizeable Jewish population, and it was probably the case that it was fairly well-to-do. The better-off residents of the City would have been the first to migrate to neighbouring districts, for many of the new Georgian houses south of the river compared very favourably with older properties in the City. We must remember Hughson's comment on Walworth Road in 1808 that it 'was lined with elegant mansions'. What this meant is that there were many first-class tall terraced houses (of which a number of well-preserved examples survive a little farther south, at the north end of Camberwell Road, immediately south of Albany Road), but there were in addition a few much grander properties which were detached and had more ground.

Just as well-to-do folk moved out of the City first, so too did they tend to be the first to move on again in later years, as yet more suburbs were created beyond Walworth. They might drift down to the hillsides of Camberwell – hills have always had a cachet around London – or farther out to the newer suburbs of Sydenham and Norwood in early Victorian days. But before this exodus became notable, more people came in for the first time from north of the river. So it was that numbers increased by the middle of the 1800s and created some pressure for a new and larger synagogue. Two remodellings had been undertaken in St George's Road in 1831 and 1841, but they were insufficient. In addition, the lease was due to expire in September 1866, and so a building committee was set up in 1865 and a fund was started to pay for a new building. In any case, the existing one was in very poor repair. The roof leaked, requiring the use of umbrellas on wet days. The ultimate indignity came when a meeting early in 1866 to promote the appeal for the new synagogue had to be curtailed because of the rain. At the opening of the new building, a Jewish journal stated: 'It is undeniable that for half a century there has been in Southwark a place of worship which for dinginess and insalubrity we do not believe had an equal'.

A site was duly leased from the Fishmongers' Company in Albion Place, later renamed Heygate Street, off the Walworth Road. It will be noticed that the removal of the synagogue from St George's Fields to the Fishmongers' Estate in Walworth exactly paralleled the history of the Baptist church known as the Surrey Tabernacle. Just as the new Baptist building had been called the Surrey New Tabernacle in 1865, so there appeared the Borough New Synagogue in 1867. It was consecrated on 7 April in that year. The architect was H. H. Collins, and the builders were Messrs Hill & Keddell. The work of the latter was evidently not proficient, for within eighteen months of the opening, ceiling plaster started to fall and 'an ominous caving-on of one of the walls' was observed. After a further, more frightening fall of plaster, an inspection was undertaken and it was concluded that the roof had been improperly constructed. The minister's house next door, built at the same time as the synagogue, fared little better. It suffered from very poor drainage and matters were not helped at all when an explosion occurred next door in 1870 in the premises of Pain's, the firework manufacturers. The house was subsequently demolished.

The synagogue was internally similar in its size and structure to the Surrey Tabernacle. It was a large oblong in Classical style. The platform occupied the whole width between

the aisles and was enclosed with ornamental iron railings. It was designed to seat 300 people, although occasionally it held up to 500. There were galleries on three sides. The first minister, Simeon Singer, was only twenty-one, but then Spurgeon had started his ministry in Southwark at a similar age. After much hard negotiation, the congregation joined a federation, the United Synagogue, in 1873.

Morris Rosenbaum, who was the minister from 1905 to 1935, wrote a very useful booklet in 1917 to mark the 50th anniversary of the new synagogue. He recorded in it that in 1888, about two-thirds of the seat holders lived in Brixton or Clapham or places farther south. This brought about some discussion about moving the synagogue again. Then, after Brixton had acquired its own building in 1904, there was lengthy consideration of a merger in 1908/09. But none of these proposals went any further. Much migration took place in the next few years from the East End, which counterbalanced any exodus from Walworth towards the south. Rosenbaum noted that in the eight years down to 1917, 244 men and 127 women had become new seat holders, but the net increase was only 22 men and 32 women. Nevertheless, the membership in 1917 was at a record level, stopping talk of moving or merging for some time.

In 1927, due to continuing problems with the 1867 building, the congregation moved into the vacant Surreyt in Wansey Street. Worship took place there until the Second World War, by which time migrations in the 1930s and wartime dispersal had depleted the numbers. The extensions of what we now know as the Northern Line prompted many Walworth folk to migrate to leafier suburbs. For most local migrants, that entailed going down to Morden, but in the case of members of the synagogue – who were mainly local shopkeepers – they were inclined to migrate to north-west London, towards Edgware. Post-war worship took place in a nearby hall, and lasted until 1961. A transfer to Brixton finally happened at that time, ending an honourable part of London's Jewish history.

Levy's the Tailor's

One of the shops that stood at the Elephant for several generations was Levy's the tailor's. Its last location was under the office block called Castle House, just beyond the railway bridge. This is where the new skyscraper called Strata now stands. Before the Second World War, however, Levy's stood at Nos 51–55 Walworth Road, on the site of the present shopping centre. In the light of the previous section on the Borough Synagogue, it serves as an example of the many businesses whose owners would have supported that synagogue, and who had first migrated to Southwark in the early nineteenth century.

The date of the accompanying illustration is clear enough, for King George V's Silver Jubilee in 1935 is being celebrated with great exuberance. Unusually, Queen Mary gets an equal role in this case, through the pictures fixed to the windows and in the lettering at the top. The King and Queen passed this shop in an open carriage on 18 June, as part of their drive through South London.

Levy's the Tailor's in Walworth Road, 1935.

Levy's was properly A. Levy & Co., with the A standing for Abraham. If I read the date correctly on the shopfront, the firm was founded in 1873. I had thought it might be much older than that, for James Pollard's famous painting of the Elephant in 1826 shows a tailor called Levy next to the Elephant and Castle pub in Newington Butts. A directory of 1832 lists the tailor in question as Emanuel Levy at No. 5. In that year, however, there were five entries in the close vicinity under the surname of Levy, plus one Israel and one Cohen. These would have been Jewish tradesmen who had probably migrated from the City, where they would previously have lived and worked. They had dispersed into St George's Fields and Walworth in the first quarter of the 1800s, when the district was seen as a new and desirable suburb.

Levy's in this instance may not have gone back to the 1820s, but it was still part of a tradition of Jewish shopkeepers in the area, most of whom would have supported the Borough Synagogue, both in St George's Road and in Heygate Street. Many of them were always coming and going, and gradually they moved out of the district, both as a place of residence and as a place of business. Levy's shop stayed on and remained with us until the late twentieth century, a survivor from the lively pre-war Elephant.

Victorian Institutions

Rowton House, Newington Butts

A couple of generations ago, everyone in the older parts of London knew what a Rowton House stood for. There were a number of them scattered around, all of them late Victorian and Edwardian in date, barrack-like, but mostly possessing an ornate roofline and having a presence that suggested something out of the ordinary.

Rowton Houses were intended as cheap hotels for working men and began as the philanthropic idea of Montague Lowry-Corry, the first and only Lord Rowton (1838–1903). He had been the private secretary of Benjamin Disraeli, the Conservative Prime Minister in 1868 and 1874–80, and stood high in the social and political worlds. He developed an interest in working-class housing and became the first chairman of the Guinness Trust in 1889. But the trust did not cater for those who might make use of an improved model lodging house. And it was that type of housing that Lord Rowton developed, initially with his own money. He pursued his aim with the close help of Richard Farrant, a director of the Artizans' Dwellings Company.

The first Rowton House was built in Bondway at Vauxhall. Lord Rowton supervised every possible detail of the building. Its foundation stone was laid on 4 August 1891 and it was opened on 31 December 1892. There were 484 beds provided in 'cubicle rooms' at the cost of just 6d (2½p) a night. In the first year, 407 beds a week were let on average. A lodging house it may have been, but its arrangements were vastly superior to previous examples of the type.

A second and larger house was opened at King's Cross in 1896. The third one, the subject of this article, was built on the western side of Churchyard Row off Newington Butts and therefore overlooked the churchyard of St Mary, Newington. There were 804 cubicles, arranged on 6 floors around 3 sides of a rectangle. The building was designed by Harry B. Measures. Although it was very large and tall for the district and might attract the label 'barrack-like', its roofline was quite ornamental, with gables and corner turrets.

It is interesting to note that the London County Council tried and failed to stop the Rowton House at Newington Butts. The council had set up a lodging house of its

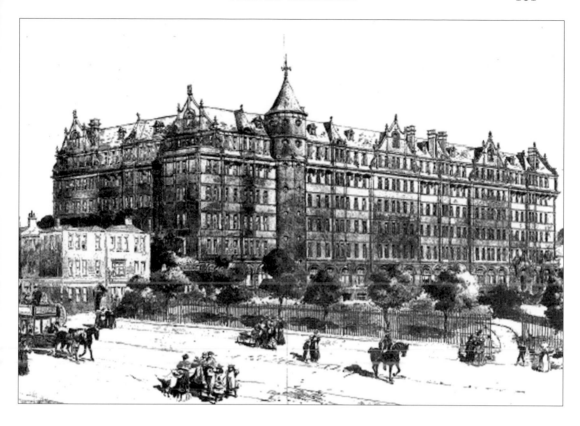

Rowton House seen standing beyond St Mary's churchyard in 1903.

own in Drury Lane, and it had failed. Subsequently, seeing the obvious success of Lord Rowton's steadily expanding empire, the council tried again with Carrington House at Deptford, which it acknowledged to be 'a Rowton House', which was entirely copied from Lord Rowton's establishments. About a hundred men left Newington Butts to lodge at Carrington House when it was opened in 1903, probably because it was nearer their places of work, but within a few weeks they had all returned to the Elephant. This telling episode clearly points to the special character of the Rowton Houses, which Lord Rowton himself had insisted upon. The council's establishment no doubt had a bossy air, and lacked the features that made a Rowton House homely, however unlikely that may seem at first glance.

Although we might properly call Lord Rowton a philanthropist, he declared of the houses that 'they are built for a business purpose'. From 1894 they were run by a limited company (Rowton Houses Ltd, of which Lord Rowton was the first chairman) and made a profit for the small number of shareholders, who had put up the capital. But it is equally the case that Lord Rowton was driven by a strong wish to develop a new type of lodging house that was warmer, more comfortable, more welcoming and the provider of services which would be popular to the residents. Each house came to have tailoring facilities, a barber's shop, a smoking room, a reading room, a general

shop and a laundry. For the lowest possible cost, a standard of service unimaginable in an old type of lodging house was offered. A Rowton House provided the atmosphere of a club. There was a certain amount of regulation. But so far as possible, the residents were left to lead independent lives.

It went further than that, it seems, for Lord Rowton had sympathy and a regard for the working man that was very similar to Samuel Plimsoll's. At the time of the opening of the house at Newington Butts, he stated his outlook very clearly to a reporter of the *South London Press* (published in the paper for 1 January 1898). He remarked, 'The way single working men have to live in London is one of the most awful blots on present-day civilization', and added:

> I have been especially gratified with the behaviour of the bona-fide working men. They are quiet, orderly, and well behaved in the extreme. They like to preserve their independence; they do not want charity, and it is a revelation to them to be able to sit in the smoking-room and chat and to take recreation in the reading-room instead of being obliged by force of circumstances to have recourse to the public-house.

It soon became apparent in the Rowton Houses that many rooms were rented permanently. About half of the rooms in each house, on average, were in that category. Further houses were opened at King's Cross, Hammersmith, Whitechapel and Camden Town. There was a stir when the Princess of Wales (the future Queen Mary) made an unexpected visit to the Whitechapel house in 1904, in the company of the Bishop of London and the Rector of Whitechapel, and praised its arrangements. By then, the Rowton Houses were being copied very widely, for example in Paris, Milan, Budapest, Vienna and New York.

The social and economic background remained broadly similar in inner London until the Second World War. The war saw a considerable dispersal of London's population. Subsequently, economic conditions improved greatly and made the original clientele seen before 1914 a much-diminished category. The perception is that the independent working men were replaced more and more by life's failures. The proud and self-respecting air that could be claimed for the first half-century waned. Eventually, in 1970, the Rowton House at Newington Butts was changed into a cheap hotel, largely for tourists, under the names of Parkview Hotel and London Park Hotel. There was a major refitting, which produced 380 bedrooms. After some years of success, a decline set in and the hotel was closed. The building remained empty for some years before being demolished.

The Horse Repository

For three-quarters of a century, the Elephant and Castle had the unexpected privilege of hosting London's centre of the horse trade. At one time there had been several competitors, of which one was Tattersalls in Knightsbridge. That renowned establishment had removed to Newmarket, and the remaining rivals had also moved

or ceased to trade and so the Elephant came to have a monopoly in London. In the mid-nineteenth century, the Great Central Horse and Carriage Repository had existed nearby, next to No. 103, St George's Road.

This equine emporium was usually referred to as the Horse Repository. Its full majestic title was the London (Elephant and Castle) Horse and Carriage Repository. It always seems to have sold many things other than horses. In later days, motors were sold on Thursdays. In horse-drawn times, carts and carriages could be bought there. It goes without saying that saddles and harnesses were always available. And at times odd lots were offered, such as a collection of old scenery from the South London Palace. Furniture was sold in the room upstairs. An advertisement in the *South London Press* on 24 September 1887 claimed that 'Upwards of 300 Horses, Carriages, & c., are Sold Every Week at this Repository'.

The repository stood at Nos 16 and 18 New Kent Road, with a very narrow street frontage consisting of no more than a tall arch. This led into a long yard, flanked by loose boxes, stables, storehouses and offices. It began in around 1880, when its proprietors were French & Briggs. A few years earlier, according to the large-scale Ordnance Survey map, there had been an oil works on the site. Later in the 1880s, the proprietor was George James Briggs. Later still, his designation in directories changed from 'proprietor' to 'manager'. This must tally with the account in a history of Tilling's, the old bus empire, that on 12 February 1895, Richard Tilling called together some friends to start a repository to sell unwanted horses. Tilling and his friends may have bought Griggs's business, but they certainly did not start it.

The repository lasted until the late 1950s, when it was overtaken by the London County Council's redevelopment of the Elephant and Castle. From before the First World War until the mid-1950s, the manager and chief auctioneer was Alfred H. Harris. He is named in the Tilling's book and was clearly the successor to Briggs. Harris was a well-known figure in the area and in the horse trade, always on duty wearing a black top hat. The repository might be said to have lasted as long as the widespread use of horses in London's streets, for in the 1950s there were still many horses drawing delivery vehicles. For example, flat-bed carts carrying hundredweight sacks of coal were commonplace at the time. As late as 1953, Bermondsey Borough Council used horses to draw its dustcarts.

The repository was not merely a place where horses were sold – at the weekly Monday auctions – but it was also where they were stabled for their owners. Entry to the sales was by catalogue at the gate. Horses would be sent for sale by private owners, farmers and tradesmen. Alfred Smith, the proprietor of the long-established undertaker's business in Southwark Bridge Road, put his ten horses into the auction in 1956. The demand for horse-drawn funerals had almost disappeared, and only four of his horses had earned any money by being used in films. Mr Smith, who did not want to part with them, bought four back, but the remaining six were destined for the knacker's yard. Since that time, of course, the demand for horse-drawn funerals has revived.

Many horses up for sale were work-worn animals, fit for light tasks at most, but very likely to go on to end their days at the knacker's. 'Sound in wind and eyes' was the standard label, and that did not say much. A catalogue of 30 August 1954 includes this

remarkable entry: 'NOTICE. Horses that are Blind in one or both eyes or have been unnerved must not be sold with a Warranty'. Indeed! When a horse that was past its best came up for sale, the steward would draw his cane across the cobbles of the yard to make the animal prick his ears and look a little livelier.

In 1905, the *Southwark and Bermondsey Recorder* reported an extraordinary case in the Southwark County Court, in which the buyer of a horse, Fredrick Davey, was the plaintiff. He had sued the repository for fraud. He claimed that an unsound horse had been sold to him for £5 15s 6d. In fact, the horse, 'which was warranted sound and quiet in harness', had firstly been sold to a Mr Lewis. But when he got it home, it was effectively lame in three legs and 'absolutely unfit to do an hour's work'. The repository then resold the horse to Frederick Davey with the same warranty. Incredibly, the case was withdrawn, after the counsel for the plaintiff considered there was no good case! Yet the repository had offered a warranty to a horse that was clearly lame. It all depended, as always, on 'the small print'. The buyers had clearly been willing to take a horse in poor condition, but they had taken the warranty at face value.

A correspondent to the *South London Press* in 1957 recalled an incident when an unmerchantable lot was a cart rather than a horse. Mr F. Lane recalled:

On one occasion a front part of a van was faked with cardboard instead of genuine steel plate, but unfortunately for the seller, as the van was leaving the premises, it touched the gate which scratched the paint from the cardboard. So instead of a "sale" there was a fight.

A painting by J. Bateman, R. A., entitled *The Elephant Mart*, was exhibited in 1949. It shows the long yard and surrounding buildings.

Skin Hospitals

One aspect of the Elephant's history that is quite forgotten now is that it once boasted two skin hospitals, one of them on the small island no less. Before the rebuilding of the Elephant and Castle pub in 1898, its neighbour, known as No. 5 Newington Butts, housed a branch of the British Hospital for Diseases of the Skin. The institution was founded in 1864 and its main building was for long in Great Marlborough Street in the West End. Eventually, it was removed to No. 20 Euston Road. If it is remembered at all today, it is for a book entitled *The Pharmacopoeia of the British Hospital for Diseases of the Skin*. It was published in 1879 and was edited by Balmamo Squire, a leading light of the institution. The branch at the Elephant lasted from 1879 to 1896. Next door to it, at No. 7 Newington Butts, there was for a while the Hospital for Diseases of the Throat and Chest. Both Nos 5 and 7 were clearly quite small.

A second skin hospital existed in the early twentieth century at No. 21 St George's Road (on the southern side). It was known as the South London Institution for Skin Diseases, and was referred to in 1908 as 'this old-established institution'. At that time it offered consultations from 2.30 p.m. to 4 p.m., and from 8.30 p.m. to 10 p.m. except

on Sundays and Thursday evenings. This suggests a strong demand for treatment for skin complaints.

A third and much more celebrated skin hospital existed elsewhere in Southwark. The Hospital for Diseases of the Skin, which was founded at London Wall in the City in 1841, was situated for many years at Nos 70 and 71 Blackfriars Road. It was closed in 1948.

The First Set of Subways, 1911

There have been two sets of subways at the Elephant and Castle. The first set served the main junction only, with iron-railed stairways at the various corners in the manner of those that exist today at Piccadilly Circus. The first subways were built by the Council of the Metropolitan Borough of Southwark in 1910/11. It has to be remembered that this was a generation before traffic lights were installed and that no roundabout existed. The only earlier control of the traffic was by policemen on point duty. A glance at photographs of the junction around 1930 gives the impression of a free-for-all, with an extraordinary gyration of motor cars and vans, electric trams, and what was still a sizeable number of horse-drawn vehicles. To these one must add the many pedestrians who risked life and limb to march across in the busiest spots.

The Southwark Metropolitan Borough Council appointed a special committee in November, 1909, to consider a set of subways under the main junction or Elephant and Castle Headway. The committee's members immediately enquired whether the London County Council would contribute to the cost. The reply was positive: half the cost or £3,000, whichever was the lower sum. Four tenders were received by February 1910, with the considerable range from £8,733 up to £15,850. The lowest of these, from Messrs Perry & Co. (Bow) Ltd, was accepted and also secured the approval of the London County Council. The contract was sealed in April, 1910. The sum of £6,000 had been received back in 1904 from the Bakerloo Line towards such a scheme.

A couple of months later, the question arose of a new arm to the planned subway system under New Kent Road, for the building on Stimson's corner had been vacated. This stood in the angle between New Kent Road and Walworth Road. The council arranged to buy a slice of the site, so that the pavement was made wide enough for a subway entrance. This was duly done at extra cost. The subways were formally opened on 1 June 1911, in a ceremony on the corner of St George's Road and Newington Butts. The Chairman of the London County Council was present. Despite the subways' value, it is clear from old photographs that many pedestrians continued to charge across the road, as they still do today.

Three Churches

The Surrey Tabernacle

The Metropolitan Tabernacle may have been a most prominent church in the life of London, and was capable of holding a few thousand people, but it had no monopoly of Baptist worship in the vicinity of the Elephant and Castle. A further congregation met in buildings on two nearby sites over the years and was known in both cases as the Surrey Tabernacle. From 1830 to 1872 its pastor was James Wells (1803–72), who had as devoted a following as Spurgeon's and an influence beyond his own flock, although in both cases on a much smaller scale than the 'Prince of Preachers'.

Wells was a Strict Baptist and was prepared to accept the label of 'hyper-Calvinist'. He did not found ancillary institutions or daughter churches, which were notable features of the Metropolitan Tabernacle's ministry, and was content to be a tireless preacher very largely in his own chapel. However, he did follow in Spurgeon's footsteps at the Surrey Gardens Music Hall in 1858, where he had a congregation of 10,000; at the Crystal Palace in the same year, on behalf of the Christian Blind Society; and at Exeter Hall on Sunday evenings in 1859, where he attracted 5,000 hearers.

Wells became pastor in 1830 of a congregation which met in Princes Place, Westminster. They then leased the Surrey Tabernacle, off Borough Road in Southwark in 1832. This had been built in 1814 for a congregation led by John Church, another strict Calvinist. This building was demolished and rebuilt in 1838, enlarging it from 600 to 1,000 seats. But Wells's success then brought a need for more space, and so it was enlarged in 1850 to allow 1,400 worshippers. The local history library in Southwark has *A Selection of Hymns from various authors*, collected by Wells, with a preface dated 23 December 1839, and marked '8th edition, sold in the vestry'. This was at the Tabernacle in Borough Road.

Finally, in Wells's later years, he had a completely new chapel erected in Wansey Street, Walworth, a quarter of a mile south of the Elephant. The foundation stone was laid on 17 October 1864, and the building was opened on 19 September 1865. It could hold 2,000 people and cost £10,500 to build; the debt was paid off by April 1867.

It was known as the New Surrey Tabernacle. Edgar Loftus Brock was the architect and John W. Sawyer of Dulwich was the builder. Its frontage was that of a Greek temple, with six Ionic columns and a pediment facing Wansey Street, along the lines of Spurgeon's great church. But it also had Greek Classical ornaments at the apex of the pediment and at its corners, but without the usual plinths. The date, AD MDCCCLXV [1865], was displayed within the pediment.

Wells lived at the Kennington end of Brixton, a fairly middle-class area in his day. Many of his flock were reasonably prosperous, as was normal in Southwark's Baptist chapels. One of them was Sir John Thwaites (1815–70), a deacon for sixteen years, who served from 1855 to 1870 as the first Chairman of the Metropolitan Board of Works, a forerunner of the London County Council. He was knighted in 1865.

James Wells died on 10 March 1872, aged sixty-nine, and was buried in Nunhead Cemetery. His monument in the form of an obelisk stands by the path leading from the right of the main gates. It states that it was 'erected by the sorrowing church and congregation', and is flanked by several monuments to members of his flock. Spurgeon, ever the sympathetic figure despite his differences with Wells, was present at the graveside when Wells was buried.

Wells had no successor as the settled pastor for many years. Nevertheless, the congregation remained in being until about 1920. Subsequently, in 1927, the building was taken over by the Borough Synagogue from nearby Heygate Street, and this flourished until the Second World War (*see under* Borough Synagogue, *above*). The congregation then moved into a nearby building, where it stayed until its closure in 1961. The old Tabernacle building was demolished in 1970 to make way for the Heygate Estate.

Walworth Road Baptist Chapel

Walworth Road Baptist chapel was a mainstream Particular Baptist church, which was used for worship between 1864 and 1969. It was demolished in 1970 due to the building of the Heygate Estate, although its site was not subsequently occupied by a block of flats.

The chapel housed a congregation which had originated in a split in 1805 from the East Street Baptist chapel (founded in 1779). There were thirty-six defectors, who initially met in a schoolroom at the back of Beckford Row, but then moved to Lion Street just south of New Kent Road. Land was taken there early in 1806 and a chapel was built at the cost of £889. It was opened on 24 June 1806. John Chin was the first and very well-regarded pastor, who added 528 members. He died in 1839.

Long before the lease on the building in Lion Street had expired, a fund was started (in 1855) to build anew on another site. One was duly found and leased for ninety-nine years from the Fishmongers' Company, on the Walworth Road frontage of the block between Heygate Street and Wansey Street. The foundation stone was laid on 3 June 1863, by Sir Samuel Morton Peto, Bt. (as at the Metropolitan Tabernacle), and the opening services took place on 19 April 1864. Messrs Searle, Son, & Yelf were

the architects, and the builders were Sharpington & Cole. The cost was £6,200. The *South London Journal* remarked that it was 'not ... distinguished by any superfluous ornamentation, while, on the other hand, it is not in any way characterised by meanness'. It had six attached Corinthian columns surmounted by a pediment, making it five bays wide, with large arched windows above, doorways below in the three middle bays, and segment-headed windows in the outer bays. In other words, it had no portico, but otherwise it resembled the Surrey Tabernacle and the Metropolitan Tabernacle; it was yet another example of the Baptist liking for Greek Classical design in the 1860s. It could hold 850 people.

The congregation's centenary was marked in March 1906. One of the speakers was Thomas Spurgeon, who was then still the pastor of the Metropolitan Tabernacle. A feature of the centenary celebrations was the promotion of the plan to raise £2,400 to buy the freehold from the Fishmongers' Company. The chapel had 402 members in 1906.

The chapel was damaged in the Second World War and was restored in 1956/57. There was an attempt under W. H. Thomas, who was appointed as pastor in 1949 after the absence of one for some years, to revive the cause through a local publicity campaign. Another Baptist congregation, from a chapel known variously as Camberwell Gate and Arthur Street, merged with Walworth Road's in 1950. In fact, it was rejoining its mother-church, for it had been formed by a split from Lion Street in 1834. In later years, local redevelopment reduced Walworth Road's congregation and threatened the building itself by 1966. In the end, it was closed in 1969 and was demolished the following year.

St Matthew's Church, New Kent Road

The mission work that led to the foundation of St Matthew's was first conducted in December 1863, by the Reverend J. G. Pilkington in Newington Hall, Francis Street (later Crampton Street). In the spring of the following year, the former Lion Street Baptist chapel was bought and was reopened as an Anglican church on 20 July 1864, by the Bishop of London. Before long, a new building was planned as a permanent church for the congregation. A site in New Kent Road was acquired, and the foundation stone was laid on 16 May 1867, by Robert Stephen Faulconer, a local businessman and philanthropist. The new church was consecrated on 7 December of the same year – a little over six months later – by the Bishop of London. The consecration was followed by a lunch at Taylor's Depository on the corner of Newington Butts and St George's Road, with Faulconer in the chair. Bishop Tait referred to him as a possible 'lay bishop of Newington'. The esteem in which Faulconer was held in Newington is shown in a printed notice of a testimonial of 1866, which states that twenty-two people had subscribed the sum of £171 10s 0d, which was used to buy a silver epergne for a dining table. Bishop Tait and the Rector of Newington (Arthur Cyril Onslow) headed the list.

It needs to be explained here that during the period from 1846 to 1877 Newington or Walworth surprisingly came under the jurisdiction of the Bishop of London,

whose diocese at all other times was entirely north of the Thames. In Newington, he succeeded the Archbishop of Canterbury, whose 'peculiar' it had long been. The Bishop of Winchester, who had controlled the Church in most of South London for centuries, did not enter into this story. In 1877, the arrangements were once again changed. The Bishop of Rochester was given control under a rearrangement and retained it until 1905, when the new Diocese of Southwark was created.

The total cost of the church was about £9,300. Of this sum, £5,000 was given by Faulconer, who also paid for the clock tower in Newington Churchyard in 1877. The architect was Henry Jarvis, who designed six churches in Walworth and a further one in Bermondsey. He personally gave £100 towards the St Matthew's building fund. Messrs Myers were the contractors.

The style of the church was thirteenth-century Gothic, with a ragstone front, brick sides and Bath stone dressings. On the right-hand side of the frontage to New Kent Road, the porch was surmounted by an octagonal stage and then a spire rising to around 100 feet, which had bands of red Mansfield stone. Within, there were cast-iron columns and an apse.

Basil Clarke, the eminent writer on churches, thought it was a 'cheap church'. But it did have a seemly presence on New Kent Road, and the spire was proportionate to the frontage and its gable. The parish was a relatively poor one, and yet the church of 1867 attracted substantial support for several generations.

In Victorian days, the church had a Temperance Society, a Band of Hope, Sunday Schools (in the Lion Street School building) and an annual Harvest Thanksgiving. The last of these helped to raise money for the church. Initially, pew rents brought in a fair proportion of income, but between 1883 and 1890 they declined from £77 to £30, while general offertories increased from £58 to £68. The overall totals were very small, and special appeals were needed from time to time. A report in 1906 states that the new Vicar, the Revd J. T. Thompson, had begun a Men's Service, which he had run with great success when he was the Senior Curate at St Martin-in-the-Fields.

T. P. Stevens was the Vicar from 1924 to 1930. Under his guidance, Martin Travers remodelled the interior in 1926/27 at a cost of £2,000. The cast-iron columns were encased in wood to resemble Tuscan columns. A wall was placed in front of the apse, and a new altar and altarpiece were installed there. Travers also designed two new windows of St Matthew and St Mark. The church was reopened and the new altarpiece was dedicated on 10 January 1928. Travers was also the architect of the new hall in 1930. T. P. Stevens wrote much about Southwark Cathedral and featured prominently in many public events in old Southwark in the 1920s. He became an honorary canon in 1937.

The last service in the Victorian building was held on 14 February 1988; the Bishop of Woolwich presided. A new and smaller church was eventually built alongside much new housing: a formula for redevelopment that has been applied to many church sites in recent decades. There is no longer a spire in New Kent Road, but a bell on a raised frame still signals a place of worship.

13

Famous Personalities of the Elephant

Michael Faraday

One of the most celebrated figures to be connected with the Elephant is Michael Faraday. He was born in Newington Butts on 22 September 1791, the son of James Faraday, a blacksmith. He was also a Sandemanian, a member of a very obscure religious sect. The family was a poor one, and so Michael received little education and had no obvious prospect of becoming a scientist. He was apprenticed to a bookbinder and might have secured a stable craftsman's life. By this time, the family had removed to Marylebone. In his bookbinding life, he began to read books on chemistry, and when his interest had become known, a customer gave him tickets to attend some lectures to be given at the Royal Institution by Sir Humphry Davy, a leading scientist of the day. Faraday duly heard the lectures and made notes of them, which he wrote out in a fair hand and bound in the most handsome manner he had learnt. He presented the result to Davy, together with a letter enquiring about the possibility of becoming a scientific assistant. Davy asked to see Faraday and was very sympathetic, but had no position to offer. Not long afterwards, however, Davy sent a letter asking to see him the following morning. Davy had dismissed his lecture assistant and offered to appoint Faraday in his place. He was to live in rooms at the Royal Institution. A little while later, he was asked by Davy to go on a European tour as his chemical assistant. The blacksmith's son from Newington Butts was going on a European Grand Tour on scientific business. Davy was lionised everywhere, and met some of the leading figures in what became the world of electricity: Ampere in France and Volta in Italy, whose names we use in everyday electrical labelling.

It was to be in the fields of electricity and magnetism that Faraday made his greatest achievements. His discovery of electromagnetic induction took place in 1831. He invented the dynamo and the transformer, making electricity a source of power. In 1833 he became the Fullerian Professor of Chemistry at the Royal Institution. The money for this had been bequeathed by a Member of Parliament called Jack Fuller. Illness had made him a restless and sleepless soul who claimed that he 'could always find repose

Michael Faraday, the discoverer of
electromagnetism, was born at Newington in 1791.

and even quiet slumber amid the murmuring lectures of the Royal Institution', for
which he was very grateful!

Faraday was commemorated locally by the naming of a street in Walworth in 1872;
by a local school being named after him; by the Faraday Garden of 1905 whose
site between Portland Street and Liverpool Grove in Walworth was the gift of the
Ecclesiastical Commissioners and which was laid out by the London County Council;
by the main room of Newington Library in Walworth Road being named in his memory
in 1927 and a bust being placed there in 1928; and by a plaque at the Elephant,
which is now fixed to the wall of the London College of Communication.

The Former Electricity Substation
In addition, there is the extraordinary former sub-station for the London Underground,
which stands on the big roundabout. It was a by-product of the London County
Council's redevelopment scheme in the late 1950s that this new electricity substation
for the Underground was designated as a memorial to Michael Faraday. The decision
to commemorate him was made by the London County Council's Town Planning
Committee, in conjunction with Southwark Borough Council. The substation was
designed as a box faced with aluminium panels, and was placed on the new central
roundabout.

It was suggested in 1959 that it would be 'a point of great architectural interest both by day and night'. The idea to commemorate Michael Faraday at the Elephant was certainly a good one, and it was also appropriate that 'the father of electricity' should be linked to a sub-station. But the link between Faraday and the aluminium box has been lost on virtually everyone who has visited the Elephant in the past half-century, and the building itself is certainly no ornament. Southwark Borough Council's small oblong plaque to Faraday, which is fixed to the front of the London College of Communication, has been many times more effective as a memorial to the great scientist.

Charles Babbage

Babbage was born in Newington, apparently at the family home in Walworth Road at the end of 1791, and he was baptised at St Mary, Newington, on 6 January 1792. His birth took place just a few weeks after Faraday, and he likewise made his name in science. But whereas Faraday came from a poor family, Babbage was the son of a banker, who was a principal in the firm of Praed, Mackworth & Babbage. His father, Benjamin Babbage, may be seen listed in the parochial rate books of St Mary, Newington, under Crosby Row, which was a terrace in Walworth Road on the eastern side, south of the present Browning Street. There was a further difference. Faraday gained huge fame in his own lifetime, but Babbage reached the same degree of recognition long after his death in 1871. This is because he is now considered as the forefather of the computer, and it is only in the past few decades that the all-encompassing development of computers has made Babbage's pioneering work much more important and practicable than his contemporaries judged. He spent much effort and money (including £17,500 granted by the government) in designing and trying to build 'difference engines' and an 'analytical engine'. The Science Museum holds original parts of his prototype difference engine, plus a complete version of the second model, which was made in 1985–91. The analytical engine was much closer to the pattern of a modern computer, but was only designed and never built.

Babbage did achieve a high position as a mathematician, and for eleven years (1828–39) he held the Lucasian Professorship of Mathematics at Cambridge University. This was the same office that Sir Isaac Newton had held from 1669 to 1702 and which Stephen Hawking has held in our own time. He once sent a letter to Alfred Tennyson, the poet, in which he stated that his lines, 'Every minute dies a man, / Every minute one is born', involved an 'erroneous calculation'. Babbage suggested that it should read, 'Every moment dies a man, / And one and a sixteenth is born', adding that this was a concession to metre, for the true ratio was 1:167! Tennyson merely changed the second 'minute' to 'moment'.

Samuel Plimsoll

Samuel Plimsoll (1824–98) is remembered today for his forceful campaign to improve the safety of British merchant ships. The Merchant Shipping Act of 1876 was his great

triumph, which instituted the practice of marking ships with a line to indicate the limit of safe loading. This has been known ever since as the Plimsoll Line. What is not known in Southwark is that Plimsoll had much to do with the Elephant and Castle.

Plimsoll's campaign was prompted by his career as a coal merchant. He became as well-informed on the coal trade as anyone in England. London was very much concerned with the inland trade, because vast quantities of coal were shipped from the north-east of England to the Thames. It was a notable part of London's economy in the past, and the collier was a type of ship that was seen widely in the Port of London. Plimsoll noticed that many ships in the coastal trade sank with much loss of life, and that colliers off the east coast were disproportionately represented in this largely avoidable tragedy.

After he was elected the Liberal MP for Derby in 1868, he pressed Parliament to attend to the matter. He then wrote a powerful book, *Our Seamen: An Appeal* (1872). The book provided him with enough leverage to secure the appointment of a Royal Commission in that year. A bill was proposed but then dropped by Disraeli's government in 1875, no doubt due to pressure from shipowners. Plimsoll caused a storm at this stage when he accused the House of Commons of harbouring 'villains' whose ownership of 'coffin-ships' was sending many mariners to their deaths each year. In the country, however, he was supported by huge numbers and the outcry over the dropping of the bill was sufficient to prompt the proposals to be reintroduced and enacted the next year. It was only in 1890, however, that all of Plimsoll's wishes became law.

Although Plimsoll began *Our Seamen* with the disarming statement, 'I have no idea of writing a book. I don't know how to do it', he did in fact write a masterly polemic. He marshalled his facts on numerous fronts and left his opponents with no leg to stand on. He quoted from the journal of the National Lifeboat Institution in 1870 that 56.3 per cent of the losses of coastal shipping occurred on the East Coast. He cited the reports of the Board of Trade that in 1868 2,131 ships totalling 427,000 tons were lost, of which 740 were colliers, either laden or in ballast, and a further 274 were carrying ores; put together, these categories amounted to almost half the overall total.

He then went into extraordinary detail to show how Parliament had intervened in numerous industries, and to what extent. He spelt out in similar detail how the insurance market was indifferent to the over-valuing of ships, which were inclined to be overloaded. Most people would have logically thought that underwriters were very strict in accepting risks that were fraudulently higher than they should have been, but Plimsoll knew the marine insurance market thoroughly from his experience as a coal merchant. He made a substantial list of shipowners and chambers of commerce in support of controls over the loading of ships, with copies of speeches and printed declarations. He referred to his fellow-MP, George Elliot, whose careful business ran more than eleven steamers in the coal trade from the Tyne to London, each with between fifty and seventy cargoes of coal a year, but with the loss of not a single ship from 1859 to 1873.

Plimsoll also painted a remarkably sympathetic portrait of working men, including mariners, which would not have occurred to many of those in Parliament. He explained

that in a lean time of his own life during the Crimean War, he lived with working men in a cheap lodging house: 'I have shared their lot; I have lived with them'. Like Spurgeon, he had wide sympathies and sensed goodness in most people. It is notable that when Garibaldi visited London in 1864, he went to see him on 16 April at Barclay, Perkins' Brewery in Park Street, Southwark, as part of a Working Men's Committee; Plimsoll proposed Garibaldi's health. It is not surprising that when he left Parliament in 1880, he became the president of the Sailors' and Firemen's Union. [Firemen in Victorian days were very often recruited from former mariners.] He ended his book with a strong peroration which appealed to a Christian outlook.

Plimsoll owned an estate at the Elephant and Castle, which extended eastwards along New Kent Road from Tarn Street, on either side of the railway viaduct. This was the stretch of New Kent Road once known as Rockingham Row. The Trustees of the Plimsoll Estates still owned this property at the time of the Blitz. Number 35 New Kent Road was the estate office before the Second World War, but No. 55 was the source of a letter from Plimsoll to Joseph Chamberlain in 1883.

The Plimsoll shoe is linked with Samuel Plimsoll, although it is generally considered that it had been invented long before as 'the sand shoe'. It originally consisted of a canvas upper with a rubber sole. It seems to be the case that the line of the junction between the two parts was likened to the Plimsoll Line from 1876 onwards, especially as water going above that line would enter the shoe. It was certainly the case that in July 1888, there was a display of the shoes in the window of the great premises of Rabbits & Sons at Nos 2–14 Newington Butts, within a setting of shingle, sand and seaweed. It was well known at the time that Plimsoll had personal and business interests across the junction and a little way along New Kent Road, and it was quite likely that Plimsoll and the Rabbits family were well acquainted.

Plimsoll set up a market on his land in New Kent Road in 1882, under an Act which was passed on 24 May (Local Act, 45 & 46 Vic., cap. 144). It was called the New Metropolitan Fish Market, but was intended to be a much more general provision market. There had been a great deal of opposition, especially from the Vestry of St Mary, Newington, and the Ecclesiastical Commissioners, a large local landowner, but Plimsoll was accommodating and generous in dealing with objections and finally won the day. Unfortunately, the market did not thrive and was closed within three years of its opening in 1883.

John Buckler

One of the foremost topographical artists of the late Georgian period, John Buckler (1770–1851), lived and died at No. 15 Rockingham Row, at the Elephant end of New Kent Road. He had become clerk to the steward of Magdalen College, Oxford, in 1785 and then served as the bailiff and collector of rents for the college's London estates from 1801 to 1849. One of these estates was in the angle of Tooley Street and Bermondsey Street in the old town of Southwark, which was long known as the Isle of Ducks; the area still includes Magdalen Street. In addition, Buckler was articled to Charles Thomas

Cracklow of Southwark, a surveyor and builder, who also made drawings of churches throughout the ancient county of Surrey, which then included Southwark.

Buckler received great encouragement from the distinguished President of Magdalen College, Martin Routh, and gradually received commissions to draw historic buildings. He produced about 13,000 in total, and exhibited at the Royal Academy each year from 1798 to 1849.

John Buckler married Ann Chessell in 1791. Their two sons, John Chessell (1793–1894) and George (1811–86) were also architects, artists and historians. John Chessell Buckler in particular devoted his attention to Southwark and produced a long series of pen and wash drawings of streets and public buildings, which are of great value to historians today. Among them were pictures of Newington Rectory and of the Fishmongers' Almshouses, both in Newington Butts. George's son, Charles Alban (1824–1905), followed in the family traditions. He wrote a book entitled *Bucleriana: Notices of the Family of Buckler* (1886), rebuilt much of Arundel Castle for the Duke of Norfolk, and designed many Roman Catholic churches. John Buckler was buried in the churchyard of St Mary, Newington.

Emily Keene

An exotic local connection was recounted in Unity Hall's book, *The Moroccan Princess from the Elephant and Castle* (Souvenir Books Ltd, 1971). The subject of the book was Emily Keene, the daughter of John and Emma Keene. She lived in the vicinity of the New Kent Road in her younger days just after the middle of the nineteenth-century. Her grandfather was the Keeper of the Horsemonger Lane Prison, which stood where Newington Gardens or 'Jail Park' exists today, in Harper Road). On 17 January 1873, she married, in Tangier, Morocco, the Prince and Grand Shereef of Wazan, and went on to lead a rather exalted life in a community very far removed from that of the Elephant and Castle. She lived into the mid-twentieth century and was certainly well-regarded in her adopted country. A report of her marriage appeared in the *South London Press* on 22 February 1873.

Charlie Chaplin

A modern pub on New Kent Road is named after Charlie Chaplin (1889–1977). He was almost certainly born in Walworth, probably near East Street, but his birth was not registered and we are unlikely to know the exact site. He first appears in any document at the age of two, in 1891, living in Barlow Street, near East Street. He lived at many addresses in Southwark and Lambeth in his poor earlier years, and then began to perform locally, especially in the South London Palace. Many writers to the *South London Press* in 1957 remembered him appearing there with Fred Karno's Boys and in performances of 'Mumming Birds'. Afterwards, he moved to the USA. Charlie visited 'his' pub in the New Kent Road in 1972.

Modern Redevelopment

The London County Council's Redevelopment, Part I
It is bad enough that this redevelopment in the late 1950s took place at all, but unbelievable that it had first been proposed between the wars. What was called the London County Council's Clearance Scheme was put forward in 1930 and seemed likely to be carried out soon after. At that time, the area was still busy and thriving, and most certainly did not need the dead hand of outside intervention. The building of the huge Trocadero Cinema and the large Burton's store showed that local enterprise was still strong. It is true that some additional provision for traffic was arguably needed, but the L.C.C. had been unwilling to pay for even a modest adjustment to the width of Walworth Road in the 1890s. The design of a suggested series of uniform new blocks of buildings round the proposed new junction might bring schemes favoured by pre-war dictatorships to mind. They reflected a crushing, we-know-better mentality, utterly at variance with the wealth of enterprise that the Elephant and Castle had possessed for decades. Fortunately, the economic depression that had set in by 1931 put an end to the 'clearance scheme'. Nevertheless, it did cause blight for a few years.

Wartime Destruction
Many people think that bombing in the Second World War destroyed large parts of South London. It would be more accurate to say that most buildings were damaged in some way, but that the vast majority survived the war. You can see the real pattern quite clearly on Ordnance Survey maps from around 1950. Destroyed buildings are indicated on them by blank spaces, by the presence of prefabs, and by the label, 'ruin'. You will soon see on a typical Ordnance Survey sheet that these features appear on a minority of sites, although there were notable concentrations.

The Elephant and Castle, unfortunately, was without doubt one such concentration. Rabbits's Corner and the Metropolitan Tabernacle were destroyed, and a large part of the larger island was razed, together with buildings on the east side of Walworth Road. The old Tarn's building in Newington Causeway went, and a large gap was created on the other side between the Alfred's Head and Southwark Bridge Road.

Much of the damage was done on the night of 10–11 May 1941, at the very end of the Blitz. It was a night of big fires and a chronic shortage of water. When the ruins had been cleared away, the Elephant and Castle looked rather skeletal, in contrast to Walworth generally. It nevertheless needs to be stressed that most buildings at the junction did still stand in 1945. It also has to be remembered that the war reduced the population, not because of destroyed buildings but because of evacuation, patterns of wartime service and new opportunities which the war brought.

Civil Defence Wardens' Posts during the Blitz existed at the Metropolitan Tabernacle (Post No. 7), St Matthew's church hall (No. 8) and Newington Butts (No. 12). The story of the last of these was later published under the title of *Reporting Post 12*. One well-known aspect of the war at the Elephant was that many people slept on the Tube platforms. In 1945, a V. E. Day party was held in Lion Street, with a large bonfire made from 'old doors, tar blocks, and old staircase, and an effigy of Hitler placed on top'. It was so successful a blaze that it had to be put out by the National Fire Service [the wartime fire brigade] (*see Len Carter*, Walworth in the War 1939–1945).

Proposal for an Airport

On 16 October 1942, the *South London Press* reported that the Royal Academy Planning Committee had proposed 'a large central airport' at the Elephant and Castle. The newspaper added: 'The airport idea depends, of course, on what planes are like by the end of the war, and whether or not they require much space for landing and taking off'. The idea sounds fantastical today, but before the war, in the days before jet engines, Croydon Airport served London with small aircraft taking off and landing on grass. Jet engines brought about a major change, and the concrete runways at Heathrow sidelined Croydon and ditched the Elephant's aeronautical prospects. Pigs might fly, and elephants ditto!

The Royal Academy's plans in 1942 were comparable with Sir Christopher Wren's after the Great Fire of London in 1666. Grand vistas, monumental squares and circuses, and unwonted co-ordination were to be imposed on the Great Wen. What is most impressive, perhaps, is the sympathetic Classical architecture, which was put forward by Sir Edwin Lutyens, President of the Royal Academy. This was most unlike the decidedly unsympathetic glass-and-steel structures that did appear after the war, stripped of any traditional ornament.

Lutyens died in 1944 and Sir Giles Gilbert Scott was his successor as Chairman of the Royal Academy Planning Committee. A further report was published in July 1944, entitled *Road, Rail and River in London*. It had nothing to say about an airport, but a great deal to suggest about new roads and roundabouts. It said:

> ... the area to the south of the River has received particular attention, and a plan has been made for the whole of the area about the Elephant and Castle. The road plan here is in urgent need of improvement; but the existing road system has a more logical basis than might appear at first sight.

A much wider junction is shown in an accompanying map, with a six-sided roundabout. This would have removed even the old buildings that survive today. The drawings in the report show buildings inferior in design to those of Lutyens.

Most notably, there is a complete disregard for the needs of business. The plans were made as if livelihoods did not matter, and that London's economy would potter along despite what was recommended. Even the first report of 1942 declared: 'It is assumed that in any plan for the redevelopment of London there would be no wharfs above Tower Bridge'. As London was still a major port in the 1940s, this is an incredible assumption. There is also not a trace of desire to see old streets retained, or familiar landmarks repaired and reinstated. One associated pamphlet, *London Replanned*, states: ' ... the present system of allowing each small property to adopt a design for itself has given our streets a chaotic and untidy appearance and made it impossible for a dignified and stately character to be achieved'. On the contrary, it was what made the Elephant and Castle a prosperous and successful place. It was exactly the same pattern that applied, say, to the Strand and Fleet Street, both of which are thriving streets to this day.

New Plans Galore

The Second World War sparked off many suggestions for a rearranged junction. The Royal Academy's idea for an airport in the vicinity may have won the prize for the most outlandish idea, but there was a general free-for-all of proposals. Whereas fifty years earlier the thought of razing an area and starting again would have been considered scandalous and even sacrilegious, it suddenly seemed normal in the 1940s. Southwark Borough Council made the eminently pertinent and sensible suggestion of a new Tube station under the junction on the lines of Piccadilly Circus, but it also came up with the rather irrelevant thought that 'more use should be made of Southwark Bridge'. In the end, only the London County Council was in control at the junction, and it was that council's aims which told. Its valuer, Mr J. E. J. Toole, stated in 1954: 'The proposals involve the improvement of the existing road intersection and the redevelopment of the area as a major shopping and commercial centre'. In the event, the former torpedoed the latter.

The London County Council's Redevelopment, Part II

Wartime destruction was one thing, but post-war redevelopment extended the trouble for many years. In the ordinary course of things, rebuilding and revival might have got going in earnest by the late 1950s. But hanging over the place was the ever-delayed threat of comprehensive redevelopment by the L.C.C. Just as blight had held the Elephant back for a few years in the early 1930s, so blight began to kill what the bombs had spared. The *South London Press* reported on 5 May 1953: 'The shopkeepers are the first to agree that the place is dying on its feet. Since the bombing it has looked like no man's land'. A further report stated that 'small shopkeepers have already begun to drift away from the Newington Butts side of the area, not waiting for the arrangements for alternative temporary sites which the L.C.C. had been endeavouring to arrange, though not entirely to the liking of the displaced traders'.

Although an elliptical centrepiece for the junction was put forward more than once, and a flyover was also suggested, a conventional roundabout eventually won the day. This one, however, was very large and involved the cutting back of all the corners of the old junction. The new plan destroyed the intimacy of the pre-war Elephant, in which a busy junction, controlled from a police box, worked within the undivided Headway. This had kept a close-knit urban air, which is missing today. The old Headway resembled the Bank junction in the City, in which heavy traffic coming from six main roads passes through an undivided junction worked entirely by traffic lights. The Elephant could have been treated like the Bank and have kept the greater part of its old character. The huge roundabout destroyed the junction as a close-knit urban and commercial centre, just as the later roundabout and flyover killed the sense of community and prospects for trade at the Bricklayer's Arms.

Newington Butts and Walworth Road were put together west of the Northern Line station, and the two ancient island sites were abolished. These changes further diminished the old busy intimacy of the area. All the land to the east was set aside for the shopping centre. A new set of subways was put in place early on, with new kerb lines being built by 1958. Initially, the Trocadero and Burton's were due to stay, but they were then condemned as well. Only the (rebuilt) Metropolitan Tabernacle and the Bakerloo station remained from the pre-war scheme of things.

The sites of Tarn's and the Trocadero made way for Alexander Fleming House, designed by Erno Goldfinger as the main office of the Ministry of Health. A hideously ugly Odeon cinema, also by Goldfinger, was placed at the back in New Kent Road. The

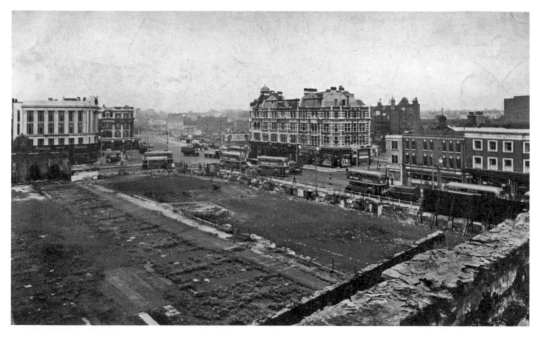

A view towards the bombed junction from the top of the Metropolitan tabernacle, 1956.

cinema was thankfully removed in 1988, and the office block was recast in 1997/98 as flats under the name of Metro Central Heights. Their new white and blue external decoration much improved the building's appearance. At the southern end of the Elephant, Edward Hollamby oversaw the new buildings of 1962–65. Hubert Bennett's twenty-five-storey Draper House, built as L.C.C. flats, was a work of concrete brutalism. It was very tall for its time, but has since been overshadowed by the much more recent Strata tower, 480 feet high, built on the site of Castle House. Its developers were no doubt not amused in 2010 when it won the Carbuncle Cup, run by *Building Design* magazine. To place such a structure next to an existing residential tower and also adjacent to a railway line is extraordinary. The L.C.C.'s southern roundabout and its subways have been removed to make way for control by traffic lights. The subways of 1958 under the main roundabout were recast in 1993 with new pictorial tiling by David Bratby and Denise Cook. This work much improved the original scheme.

Since the end of the 1990s a new general scheme for the area has been debated endlessly, but unlike the L.C.C.'s plans, this one has the replacement of the Heygate Estate as its central feature. The estate is not discussed in this book. Changes at the Elephant proper certainly need to avoid the mistakes of the previous general scheme outlined above.

The Elephant and Castle Shopping Centre

The Elephant and Castle Shopping Centre was opened on 26 March 1965 by Ray Gunter, the MP for Southwark who also served as Harold Wilson's Minister of Labour. The centre had cost £2 million and had been designed by Boissevain & Osmond for the Willett Group of Companies. Their plan had been favoured out of thirty-six schemes to create 'a busy High Street in one'. After a year, however, only 65 per cent of the shops had been let. Of the three original floors, the top one was practically deserted. Eventually, after some years, it was enclosed as offices. Even the middle floor was noticeably quieter than the lowest one.

Successive owners tried to improve the centre. The most enterprising was UK Land, who made big changes in 1990. Above all, the exterior was repainted. Once described as 'murky green', it was famously made pink. Later, it became a more subdued red. But the chief change was to put market stalls in the 'moat' and also some kiosks and stalls inside. The whole place got livelier, at least at the lowest level. Tesco and Iceland have been the supermarkets within the centre.

In general, the normal larger stores were few in number. W. H. Smith's was prominently placed in the middle of the centre from the beginning, initially spread over two floors. Woolworth's had a large store next to it for many years, a successor to their shop in the pre-war Walworth Road. The old Green Shield Stamps once had a store at the Walworth Road end of the centre. In 1965, all this may have seemed very up-to-date. But the demolitions for new roads before 1965 had already killed the area as a focus of shopping, and then the arrival of 'hypermarkets' and warehouses in places such as the Old Kent Road largely made it just a phase of history. In the earlier plans for the area's present redevelopment, the shopping centre was due to go, but it now seems likely that it will remain.

For a while in 2010/11, the Studio at the Elephant was based in the shopping centre. It was run by two artists, Rebecca Davies and Eva Sajovic, and contributed much to an interest in the area through a programme of varied events.

Elephant and Castle Recreation Centre
The Elephant and Castle Recreation Centre replaced the Manor Place Baths in 1978. The old baths had been the typical set of Victorian 'baths and wash-houses' for Newington parish. The days of 'slipper' or personal baths and of laundry being taken to wash houses had gone by 1978. The successor buildings catered for more than just swimming. There were still three swimming pools, but they were now joined by a sports hall, four squash courts and a 'Health and Fitness Suite'. It is noticeable that an early leaflet for the centre devotes a whole page to 'Fitness Terminology'. A cafeteria was also provided. The building had a rather short life, falling into significant disrepair. It was demolished in 2012/13 to make way for a further fresh dawn.

A Tour of the Elephant and Castle in its Heyday, and a Peroration

The layout of the Elephant and Castle in its heyday will now be toured and described, with comments from readers of the *South London Press*, whose memories were published over several months in 1957/58. The newspaper had offices above the Bakerloo Underground Station and began the series as the London County Council's redevelopment scheme was about to sweep away familiar landmarks.

The central junction existed roughly where the big roundabout is situated today. The Victorians liked to call it the Elephant and Castle Headway. The old junction was a large expanse of undivided roadway, from which ran (in clockwise order) Newington Causeway, New Kent Road, Walworth Road, Newington Butts, St George's Road and London Road. The corners of all these roads were substantially moved back by the L.C.C. in the late 1950s and early 1960s, and so the present junction is much wider. There are two further major differences. Firstly, there was no wide road (or 'motorway', as I call it) running south from the junction, as we have today; instead, Walworth Road and Newington Butts both ran up to the junction on either side of the two islands at

Opposite page: A map of the Elephant in its heyday. The map comprises extracts of Sheets 76 (Waterloo & Southwark) and 89 (Kennington & Walworth) of the 1914 edition of the 25th survey (by kind permission of Alan Godfrey maps,www.alangodfreymaps.co.uk).

Key to Map

1	Elephant and Castle pub	10	The Metropolitan Tabernacle
2	Elephant and Castle Headway	11	King's Hall
3	Alfred's Head	12	South London Palace
4	Site of Tarn's	13	St Mary Newington Churchyard
5	Rockingham Arms	14	Rowton House
6	Elephant and Castle Theatre	15	St Mary Newington Almshouses
7	Horse Repository	16	Midland Coal Depot
8	Rabbits's	17	The Borough New Synagogue
9	Great Northern Coal Depot	18	Surrey Tabernacle

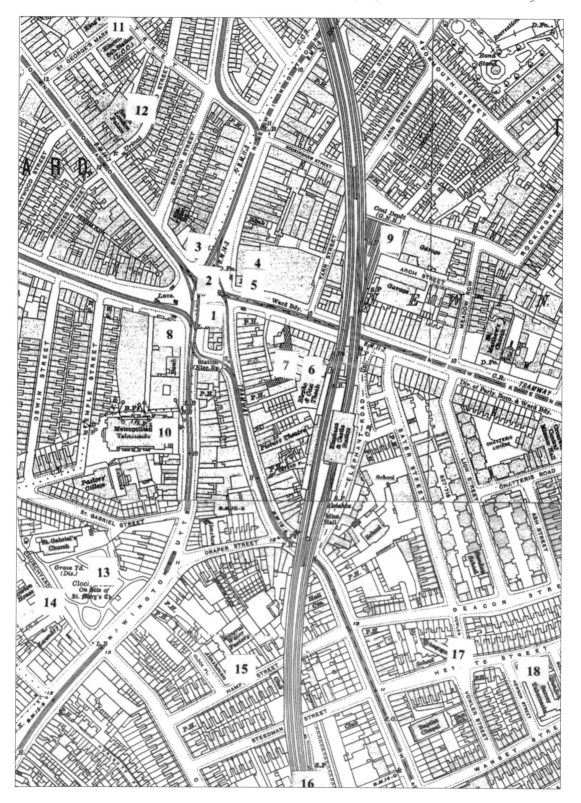

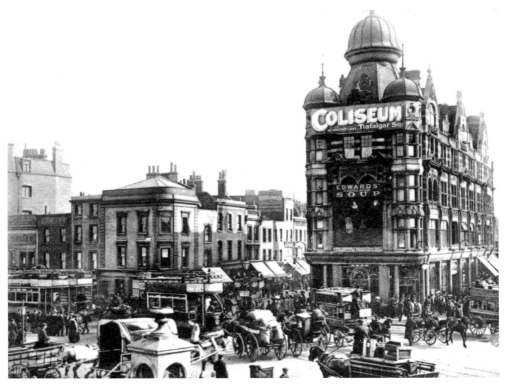

The Elephant and Castle pub from the junction, with Stimson's Corner on the left.

the heart of the Elephant, and finished on either side of the Elephant and Castle pub. Secondly, the smaller island to the north, on which the pub stood and from which it presided over the junction, stuck out beyond the opening into St George's Road. On the north side of the junction, the very wide entrance to Newington Causeway was divided by a drinking fountain in the middle. This had been built by the Vestry of St Mary, Newington, in 1859, at the expense of one of its members, Ambrose Boyson. It was formally opened to public use on 14 December 1859. Many readers of the *South London Press* in 1957 remembered it when 'flower girls' set up their pitches around it.

The landmark on the left-hand corner of Newington Causeway was the Alfred's Head pub (No. 140), which occupied the curve round into London Road. Beyond it, there were mostly small shops towards the railway bridge. On the right-hand side, bigger and grander buildings existed. The corner with the New Kent Road was occupied by the Rockingham Arms pub, which had a tall turret from 1888 onwards. Next to it along Newington Causeway stood the substantial premises of Tarn's, which became Isaac Walton's a few years before the First World War. The shops beyond had relatively narrow frontages, but formed a terrace that was taller and more stately than the opposite side.

Going down New Kent Road, Tarn's second great façade came after the Rockingham Arms, as far as Tarn Street. This elegant building was taken over by Sandow's in 1911, and later by the World's Stores. In 1930, the Trocadero was opened on the site,

and stood there until 1963. Samuel Plimsoll owned much of the next block and due to him, coal merchants abounded there. On the south side of the road, Dunn's the tailor's had a tall building on the corner with Walworth Road, which was built around 1911 on what had been known as Stimson's Corner after an auctioneer's. A little way along came the Horse Repository, with only an arch for its frontage. Associated with it was the Silver Grill Restaurant. Three doors from the railway was the site of the Elephant and Castle Theatre and, from 1930, the cinema that was eventually called the ABC. Beyond the viaduct was the well-remembered military recruiting office at No. 38, where a recruiting sergeant was a familiar figure; the Palatinate, an estate of tenement flats with shops below (the flats were said to cater for 'a grade higher in the social scale' than the working class); and the Crossway Mission, a large Congregational church at No. 92, which replaced the Murphy Memorial Hall in 1912. There is still a Crossway United Reformed church today.

Walworth Road was a narrow street where it reached the junction. The east side included the Black Prince pub, Levy's the tailor's, many of Hurlock's shops and later a Pyke's Circuit cinema, where Doyle's boot shop had been. These all stood before the railway. Elephant Road ran off to the left beyond the viaduct, which housed Spurgeon's almshouses; on its south corner with Walworth Road, stood the old Baldwin's shop, still happily a part of the local scene much farther along. On the west side of Walworth Road, the Flying Horse pub was very close to the railway, on the Draper Street corner. Going back towards the junction, there were more of Hurlock's shops; the Underground station on the corner with Short Street; and lastly, the small island which

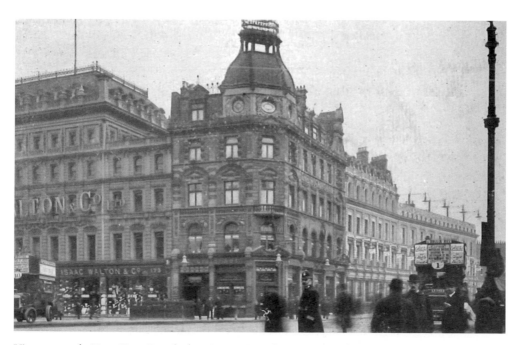

View towards New Kent Road, showing a No. 1 bus entering the Headway, with the turreted Rockingham Arms prominent in the middle, and Isaac Walton's occupying Tarn's old premises.

was filled from 1898 by one long building, most of which was the Elephant and Castle pub.

On the other side of that block, in Newington Butts, No. 7 [No. 5 after 1898] was a well-known café called Lockhart's Cocoa Rooms. Before the rebuilding of the block in 1898, this had been the address of the British Hospital for Diseases of the Skin. A tea dealer's called Hardy's stood at No. 3. Much farther down Newington Butts was the King and Queen pub at No. 105. Small shops continued all the way down to where Kennington Park Road begins. But there was also Langton & Bicknell's, sperm oil manufacturers, at No. 89. The name of Bicknell had long been eminent in scientific and commercial circles. On the other side, Rowton House loomed large from 1897 to the south of St Mary Newington churchyard. In the churchyard itself stood the tall clock tower built on part of the site of the old St Mary's, and on the side farthest from the main road there was the small mission church called St Gabriel's. A road named St Gabriel Street joined Newington Butts in between Nos 46 and 48. Shops lined the road in this part. Between Nos 28 and 30 there was a narrow entrance to the St Mary Newington Schools, which stood behind. Going back to the Headway, the Metropolitan Tabernacle stood next, but it was set back from the street, and its façade did not have the presence that it now enjoys.

Then, on the corner with St George's Road, came Rabbits & Sons. This was the centre of the universe to many. 'I spent my courting days at the Elephant', wrote Mr J. Wells, 'and always met the young lady at Rabbits, the boot shop, where we would decide where to go for the evening'. Mrs A. E. Ashley worked there: 'I was born ... in 1886, left school at 13, and was offered a job at 2/6 a week in Rabbits Boot Stores'. Mrs M. Gaydon also: 'My first job was at Rabbits, when I was 14, and worked from 8 a.m. to 6 p.m. for 3/6d. a week, inking button holes for shoes. I put more ink on my face and hands than on the button holes'. She was then taken by her grandfather 'to Lockhart's opposite, where I had a mug of tea for a 1d. and a lump of Tottenham cake for 1d., a good blowout for 2d'. Mrs A. Robertson stated: 'My late Dad worked at Rabbits as a bootmaker ... He worked there for 50 years [as] a first-class handsewn man'.

Round the corner, as a neighbour to Rabbits, stood Taylor's Depository, a large furniture warehouse with a monumental façade. The first side-road, Temple Street (later Pastor Street), had a pub on each corner: the Fishmongers' Arms at No. 5 and the Pineapple at No. 7. The next side street, Oswin Street, housed the Castle Brewery. It was run by Gillman & Spencer, who called themselves 'scientific brewers'. To make up for all this beer, the opposite side of St George's Road boasted at Nos 6–10 the Livingstone Temperance Hotel. Back to the junction, past the hotel, you came to Upton's Corner, named after the great hat emporium of 1883. This led round to London Road, which was lined with shops and pubs up to St George's Circus. Among them, the South London Palace loomed large at No. 92 on the east side, and also in people's memories. Kate Carney's appearances were widely recalled, especially during air raids in the First World War. She would say: 'If you've got the pluck to come, I've the pluck to entertain you'. On the other hand, of course, 'no mercy was shown to a bad turn'. On the same side, the Bakerloo Tube station was opened in 1906, partly on the site of the Electric Dining Rooms. Next to the station, there were stalls in Skipton Street. A popular one,

which offered oysters, was run by 'Old Tosh'. Oysters were cheap and widespread in Victorian days; two shops in Walworth Road also sold them. On the west side of London Road the two Palmer's shops were well-known: Alfred ran No. 48 as an 'eel pie house' and William had No. 39 as an 'eel and soup house', 'where', Mrs A.E. Ashley wrote, 'we had a feast for 1½d. – a lovely basin of soup and a chunk of bread'. And so back to the Alfred's Head, where we began.

The old Elephant and Castle was a joyous and occasionally wild place. People would go there to shop, eat, drink, and to be entertained. Mrs J. P. Hitchin called it 'a boisterous place ... when all the alleys and courts on Saturday nights teemed with life and many nefarious activities'. Another writer commented: 'The police used to be busy at the pubs on Saturday nights.' The relief of Mafeking in the Boer War in 1900 prompted riotous celebrations. Mr E. G. H. Jacobs recalled: 'At the Rockingham on Mafeking night two sweet young ladies walloped my bowler hat with their umbrellas when I refused to buy them "half a quartern of gin and two out".'

I like the comment from Mrs A. E. Kinsley, 'I still think of dear old Walworth in the happy days when we could dance to barrel organs and nobody took any notice.' She was lucky that Charles Babbage had long gone from the area, for he had campaigned strongly against them in later life. But her comment spoke for many. The Elephant was independent-minded, full of both grand propriety as at Tarn's and of Cockney exuberance. It was an enormous engine of trade, transport, attractions and jollity. Nobody had planned it, but it worked as an unrivalled centre of life. I much lament its destruction and trust that the copious evidence presented in this book will have brought my readers to the same verdict.

Tom Thurlow, the landlord of
the Elephant and Castle pub,
rings time for the last time before
its demolition, 1959. (*Express
Newspapers*)

Palmer's eel and soup house at
No. 39 London Road, opposite the
South London Palace.